LICHFIELD PUBS

NEIL COLEY

AMBERLEY

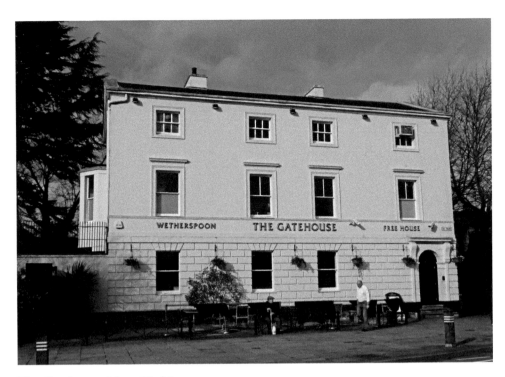

The Gatehouse, No. 1 Bird Street

This book is dedicated to the publicans of Lichfield.
Please keep up the good work!

First published 2016

Amberley Publishing
The Hill, Stroud
Gloucestershire, GL5 4EP

www.amberley-books.com

Copyright © Neil Coley, 2016

The right of Neil Coley to be identified as
the Author of this work has been asserted in
accordance with the Copyrights, Designs and
Patents Act 1988.

ISBN 978 1 4456 5138 5 (print)
ISBN 978 1 4456 5139 2 (ebook)

British Library Cataloguing in Publication Data.
A catalogue record for this book is available from
the British Library.

Typesetting by Amberley Publishing.
Printed in the UK.

Contents

	Map	4
	Introduction	5
Chapter One	The Market Place, Market Street, Bore Street and Dam Street	7
Chapter Two	Tamworth Street and Greenhill	26
Chapter Three	St John Street, Frog Lane, Wade Street and the Friary	44
Chapter Four	Beacon Street, Sandford Street and Queen Street	54
Chapter Five	Bird Street	69
Chapter Six	Lombard Street and Stowe Street	82
Chapter Seven	Out of the City Centre	86
	Acknowledgements	95

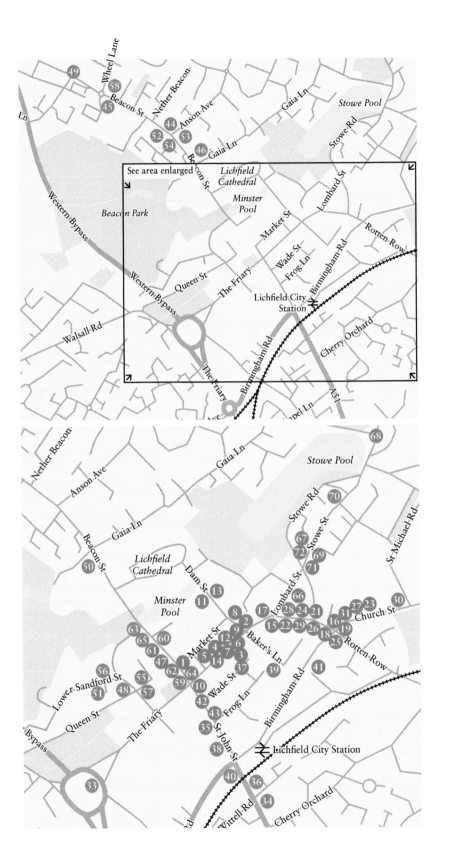

Introduction

There is nothing which has yet been contrived by man by which so much happiness is produced as by a good tavern or inn.

Dr Johnson

Pubs are, without doubt, one of the great British inventions. Other places around the world have tried to copy the atmosphere and ambience of the British pub, but they invariably get it wrong.

But what makes a perfect pub? We all have our own ideas about the sort of public house in which we like to spend our well-earned leisure time. The writer George Orwell, in an essay written in 1946 called 'The Moon Under Water', thought he knew. The perfect pub, in his view, was situated down a secluded side street, did not have music playing, served bar snacks (as well as aspirin and cigarettes!) and employed barmaids who knew all customers by name.

Whatever makes a perfect pub is, of course, down to personal choice, but there is no doubt that everyone will be able to find one to suit their tastes in Lichfield whether you want a quiet and snug little corner to read your book, loud music to tap your feet to, a full meal to savour or a simple bag of pork scratchings to nibble as you read your newspaper – all of these and more can be found in the ancient city of Lichfield.

Today there are approximately thirty licensed pubs and bars to choose from in the city. At one time that figure would have been regarded as a paltry one. In 1732 there were eighty inns and taverns in Lichfield, plus numerous beerhouses that, as the name suggests, were only licensed to sell ale.

The reason Lichfield had such a large number of licensed premises in the past is twofold. Firstly the city was situated in the middle of the country on the main coaching routes between north and south and was a highly suitable stop for coaches to drop their passengers for an overnight stop and a meal. As a result Lichfield became renowned for its coaching inns, some of which, like the Swan and the George in Bird Street, were particularly well known and constantly busy with visitors. Secondly, before the building of proper army barracks in the city and later at Whittington, houses in Lichfield often provided quarters for the soldiers stationed in the city. As a result it made sense for those places to obtain licences to make and sell beer and to become public houses. For example, in 1779 there were seventy soldiers billeted at the George, sixty-five at the Swan, thirty-four at the Harts Horn and thirty each at the Kings Head and Old Crown. The smaller public houses had fewer soldiers quartered, but even the poorest one had ten troops staying on the premises.

With so many soldiers around at that time, it inevitably followed that as well as there being a plethora of public houses in the city, there would also be a large amount of prostitution. The tradition of Lichfield brothels goes back a very long way. In 1466 a woman in Butcher Row (now called Conduit Street) earned £3 by making her home and herself available, day and night, to members of the household of the Duke of Clarence when he and his entourage visited the city. In the fifteenth century Bacon Street (Beacon

Street) was the main area for brothels. In 1485 three brothels were also recorded in Wade Street, Butcher Row and Greenhill.

The presence of so many pubs, along with soldiers out for a good time, also led to Lichfield occasionally becoming an unruly place, particularly in the Greenhill area. Incidents of drunkenness, poor behaviour and sometimes violence involving soldiers and the local populace were increasingly common and led the city fathers, by the early years of the twentieth century, to look for ways to cut down on the number of drunken incidents. That trend, allied with a burgeoning Temperance movement in the years before the First World War, led to more stringent licensing laws and a steady reduction of the number of public houses in the city. By 1910 the number had fallen to fifty-three and by 1931 the figure had dropped to forty-three.

However, such things did not detract from the quality of Lichfield beer. When George Farquhar, in 1705, wrote his play *The Beaux' Stratagem*, after staying at the George Hotel, he was very keen to praise Lichfield's beer. One of the characters in the play, William Boniface, the landlord of the George, describes Lichfield ale in glowing terms saying it was 'as smooth as oil, sweet as milk, clear as amber and strong as brandy'. By 1769 Lichfield ale had a national reputation, and in 1776 the city's most famous son, Samuel Johnson, and his friend and biographer James Boswell praised it. By the late eighteenth century a brewing trade in which maltsters produced ale for retail had grown up. By 1834 there were three brewers and nineteen maltsters in the city, mostly situated in the Greenhill, Tamworth Street and Lombard Street area. In 1848 John and Arthur Griffith, who were originally wine merchants, opened a brewery in Beacon Street with a malthouse on the site of the present-day registry office (formerly the city library). In 1864 John, Henry and William Gilbert formed the Lichfield Malting Co. in Tamworth Street, later building a malthouse on the north side of the railway line. The Gilbert's and the Griffith's companies merged in 1869 to form the Lichfield Brewery Co. and in 1873 a new brewery was built in Upper St John Street and a malthouse constructed south of the city station. Burton on Trent brewers Samuel Allsopp & Sons eventually bought out the company in 1930 and the long history of Lichfield brewing had ceased by the following year, although the Lichfield Brewery Co. continued to exist for some time in name only.

Brewery companies in Lichfield may have come and gone but city centre pubs today still seem to be thriving and there has recently been a trend for micropubs or small bars to open up and fill a niche market, particularly where real ale and craft beers are concerned. However, researching this book has made me all too aware of the large number of public houses that have disappeared over the years. This book will look at the history of those lost pubs, some of them gone but not forgotten, as well as examining the ones that are still with us, many of which are so steeped in history and tradition that their very origins have been lost in the swirling mists of time.

Each chapter in the book examines one particular area of the city and within that chapter the existing pubs, in alphabetical order, are listed, followed by those now no longer with us, also organised in alphabetical order. I very much hope that you enjoy reading about the city's pubs, that you discover something about their history and, most importantly, are encouraged to visit some of the many splendid, fascinating and historically rich Lichfield Pubs.

Chapter One

The Market Place, Market Street, Bore Street and Dam Street

Lichfield's Market Place has been the scene, over the centuries, of great drama. In 1651 George Fox, the founder of the Quaker movement, ran through the Market Place barefoot crying 'Woe unto the bloody city of Lichfield' – what he meant and his reasons for his actions are open to debate. Criminals were whipped and pilloried in the Market Place and the last person sentenced to be burned alive for heresy in Britain, Edward Wightman, met his grisly and painful end in the Market Place in 1612. Close by was born Samuel Johnson, probably the greatest writer of the eighteenth century. His statue now sits broodingly in the corner of the Market Place, facing the house where he was born.

The area around Lichfield's historic Market Place used to abound with pubs but today there are but a few. Some like the Star in Bore Street, the Cardinal's Hat in Tamworth Street and the Eagle in Market Street disappeared many years ago and few records of their existence now remain. Others have closed more recently and a great deal is known about them. Dam Street itself had several public houses in the nineteenth century; today there are none. However, the area's pubs that do exist are all worth exploring.

1. ANGEL INN, Market Street (c. 1750–present)

One of those certainly worth visiting is the Angel Inn, which is situated at No. 4 Market Street, a short walk from Johnson's birthplace.

The Angel was first listed as a beerhouse in around 1750, although a sign on the outside of the pub claims that it has been a licensed premises since 1716. One of the city's famed coaching inns in the early years of the nineteenth century, the Lichfield Shepherd coach ran from the pub to Birmingham at 8 a.m. each day, the coach being named after former landlord Joseph Shepherd.

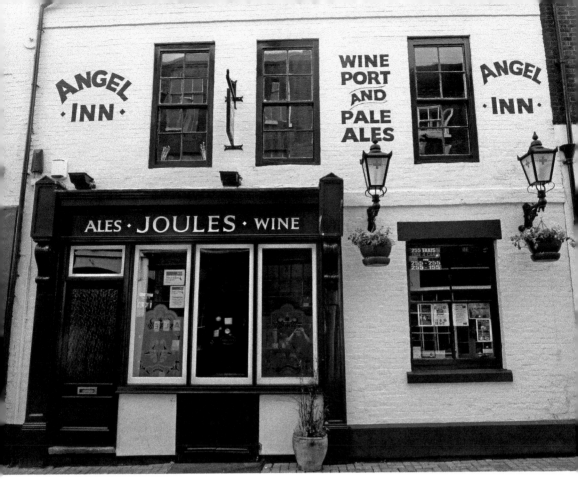

The Angel Inn.

In the 1850s the Angel must have been doing reasonably good business, as the publican at the time, Edward Orgill, was able to employ two general servants and an ostler. Also listed as staying at the pub in the census of 1851 was Thomas Nolan who was in the city recruiting men for the Staffordshire regiment.

From 1885 to 1904 Charles Small ran the Angel and, according to the census of 1891, doubled up as both an innkeeper and a cooper. Although falling foul of the licensing laws in August 1902, when he was fined for serving during prohibited hours, he managed to hang on to his licence.

The Angel very nearly closed in March 1929 after the licensing authorities suggested that it and the nearby Red Lion could lose their licensed status due to the number of other public houses nearby. However, because the Angel was 'scrupulously clean', and the authorities could not find a 'better conducted house in the city', it survived, whereas the unfortunate Red Lion lost its licence.

In 1978 the pub changed its name to Samuel's but in 2014 it reverted to its more traditional name. Now owned by Joules (a brewery that was reformed in 2010 after being bought and closed down by Bass in 1974), the Angel is very popular today for its innovative range of drinks and for its bar food and friendly atmosphere.

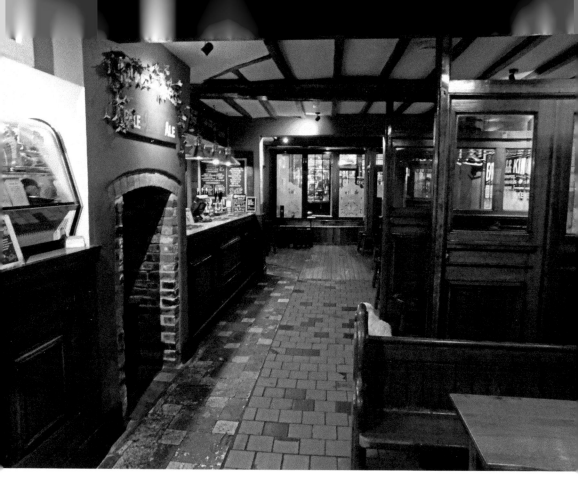

Inside the Angel Inn.

2. EARL OF LICHFIELD ARMS, Conduit Street (pre-1833–present)

The Earl of Lichfield Arms has long been known locally as the Drum, the nickname deriving from the time in the 1830s when an army recruiting sergeant would stand outside the pub literally drumming up new recruits.

Situated in Conduit Street (originally known as Butcher Row) opposite the Market Place and the Victorian corn exchange building, the pub, in 1833, was originally a beerhouse known as the Masons' Arms and the licensee was Francis Middleton. By 1842, following the purchase of the building by the local aristocratic Anson family, it had been renamed the Earl of Lichfield Arms.

The 'Drum' seems to have been the sort of establishment that encouraged licensees to have a long run in charge. Frederick Marshall ran it from 1861 to 1896 and George Burden was the licensee from 1906 to 1940. The latter was also listed in the 1911 census as a tailor and so perpetuated the habit of Lichfield landlords holding down an alternative occupation as well as that of running a pub. It was also George Burden who, in 1916, was fined £2 for having a faulty coal-weighing machine that belonged to Lichfield Corporation and for which he was the toll collector.

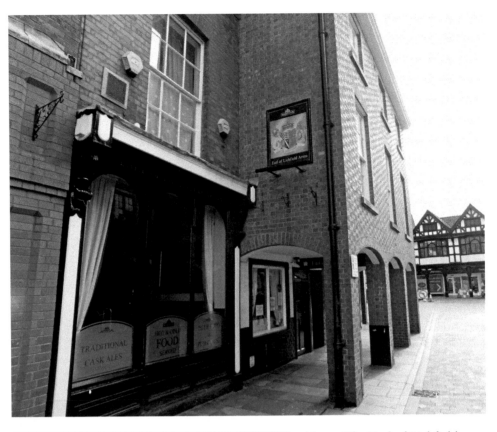

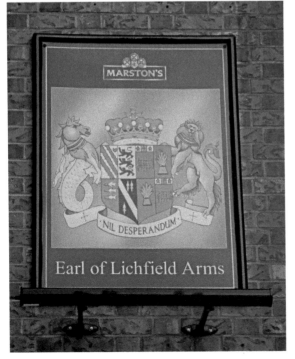

Above: The Earl of Lichfield Arms, aka the Drum.

Left: The Earl of Lichfield Arms pub sign.

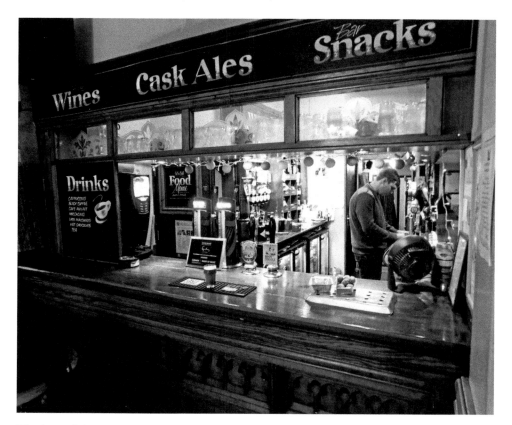

The bar of the Drum.

In 1956 the licensing authorities briefly considered closing the pub, which at the time was owned by Messrs Marston, Thompson and Evershed. After a brief consideration, however, they renewed its licence.

In the 1970s the pub expanded into the barber's shop next door barber's shop and the two floor levels of the original enterprises can clearly still be seen in the pub.

Today the Earl of Lichfield Arms remains a busy and very friendly city centre pub with a dedicated clientele and with regular live music sessions.

3. GEORGE IV, Bore Street (pre-1750–present)

A short walk from the Earl of Lichfield Arms stands the George IV near to the city's guildhall.

Previously known as the Old Golden Ball, it dates from at least 1750.

It was renamed in the 1830s in honour of King George IV and for many years in early Victorian times was run by Thomas Stringer, who was listed in the 1851 census as being both an innkeeper and organist.

In 1887 the pub, recently taken over by C. A. Hedges, was advertised in the *Lichfield Mercury* as having 'wines, spirits and beers of the finest quality' along with 'Choice cigars. Good stabling. Loose boxes.'

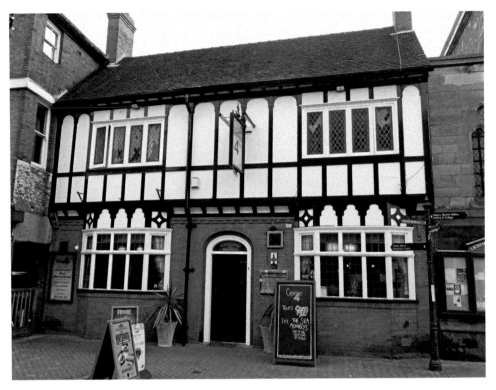

Above: The George IV.

Below: The interior of the George IV.

Rather strangely, from the 1850s to the 1880s, part of the building was leased to the Lichfield police force, which used rooms at the rear of the pub until the local constabulary eventually moved into accommodation at the guildhall. In the 1890s the George IV was one of the regular meeting places of the city lodge of the 'Royal Antediluvian Order of the Buffaloes' (known as the Buffs).

Today the pub remains an attractive and lively venue and hosts regular live music nights popular with young people.

4. SCALES, Market Street (pre-1700–present)

The Scales stands at No. 24 Market Street, a short stroll from the Market Place. It is another of Lichfield's ancient inns and was where the city's first Freemason's lodge was established in 1740.

The name of the pub derives from the time when it was the venue for the jockey weighing rooms at the time when the very popular Lichfield race weeks were held in various locations around the city, before the racecourse was permanently moved to Whittington Heath. In the early 1970s, according to Vivian Bird in her book on the history of Staffordshire, the pub's sign showed a jockey, dressed in blue and yellow silks, seated on weighing room scales.

The two race weeks, steeplechasing in the spring and flat racing in the autumn, were an important part of Lichfield's social calendar in the eighteenth and nineteenth

The Scales.

centuries until they were finally abandoned in 1895 with the opening of Whittington Barracks. The most important year in the history of Lichfield races was 1769 when the famous racehorse Eclipse came first in the King's Plate (worth 100 guineas to the winner). Eclipse would go on to win eighteen consecutive races before retiring in 1771. In the eighteenth century Lichfield races also attracted their fair share of violence and controversy. In 1748 antipathy between the two main political parties, Whigs and Tories, turned nasty when the Duke of Bedford, the national leader of the Whig Party, was badly assaulted by rivals at the racecourse.

From 1879 to 1905 the landlord of the Scales was Charles Smallwood who, as well as being an innkeeper, also ran a tobacconist business. If that was not enough to keep him busy he was the proprietor of livery stables and ran a carriage and cab hire company that was based at the pub. Unfortunately he died in June 1905 after fracturing his skull when his trap overturned after his horse bolted, apparently spooked by Mr Smallwood striking a match to light his cigar. His son, Charles H. Smallwood, took over the running of the Scales and the cab business, but his life also ended tragically when he was found in Torquay, in April 1923, with a loaded gun by his side. The inquest's verdict was that he had killed himself while suffering from temporary insanity following the recent death of his wife.

In July 1925 the pub was advertised in the local press, providing us with a brief snapshot of what the pub was like at the time: 'The Scales ... is now under new

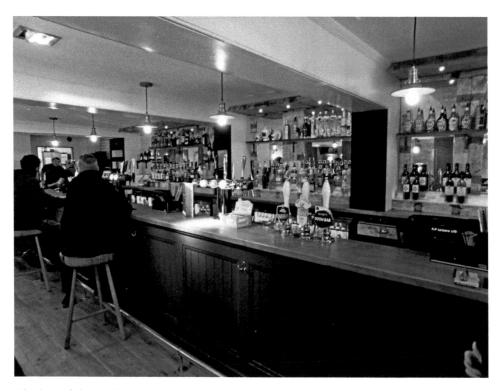

The bar of the Scales.

management. All mild and bitter ales, wines, spirits of the best quality. Garage accommodation for travellers and motorists. Bed and breakfast 5 shillings. Free garage for farmers and market gardeners on market days. Proprietor R.C. Cornwell.'

The Scales almost closed in the 1930s when licensing magistrates suggested that there were too many pubs in the Market Street area. However, the pub was saved from closure by the building of a Woolworth's store on the opposite side of the road, which seems to have attracted more business to the Scales.

A popular feature of the pub in the 1930s was the weekly boxing bouts held each Friday. On 10 February 1933, for example, one of the contests was between 'Kid' Payton and 'Banjo' Malin, both fighters coming from Smethwick. December 1933 saw fighting of a different sort when a 'street fracas' took place outside the pub when a soldier and two civilians, all of whom had been drinking in the Scales, were arrested for brawling.

Thankfully such events have long gone and today the Scales, recently refurbished, remains a lively pub in the heart of the city, popular for its good-value food.

A number of other pubs have sadly disappeared from this area of Lichfield.

5. CASTLE, Market Street (pre-1793–1963)

The Castle Inn at No. 16 Market Street was first mentioned in 1793 when the landlord was David Cox. His son John took over the licence in 1818 and ran the pub until 1850. The final landlord of the Castle was William Gallimore and the pub closed in 1963. The attractive building that once housed the Castle Inn is now the city's Oxfam shop.

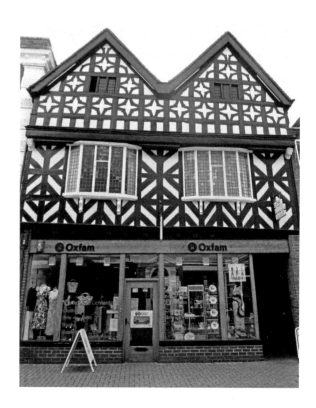

The ex-Castle.

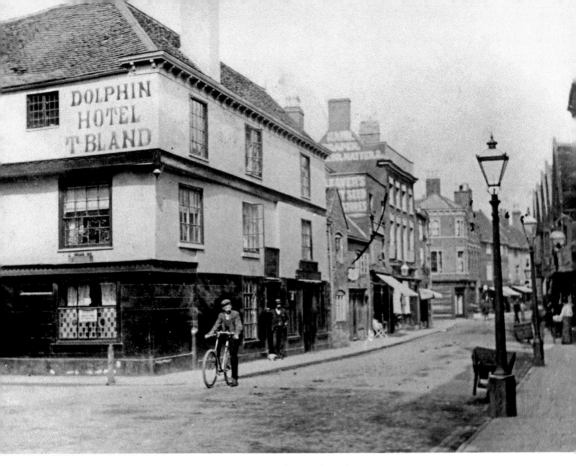

The Dolphin, the corner of Bore Street and Breadmarket Street.

6. DOLPHIN, Breadmarket Street and Bore Street (pre-1818–1907)

The three-storey Dolphin Inn was situated on the corner of Breadmarket Street and Bore Street. Henry Genders was the first listed landlord, and when he left in 1831 his furniture, beds, mattresses, tables and beer-making equipment such as buckets, mash tub and a cooler with pipes were sold by auction.

The last licensee was Ernest Percy Woodfield and the pub was closed in 1907. The actual building was demolished in 1912 and the new building, completed the following year by Lichfield builders J. R. Deacon, became Branch 13 of the Walsall and District Co-operative Society and later various clothing shops.

7. GOAT'S HEAD, Bore Street and Breadmarket Street (pre-1811–1970)

The Goat's Head occupied a prominent position on the corner of two important city streets. The building, much altered, is now used by Barclays Bank.

The first recorded landlord, in 1811, was William Hobday. From 1833 Margaret Slater was the licensee and she ran the Goat's Head until 1880. Born in Edingale around 1796 she was widowed early, was wealthy enough by 1851 to employ servants and was one of the many examples in the city of independent women who were in charge of Lichfield public houses in the nineteenth and twentieth centuries.

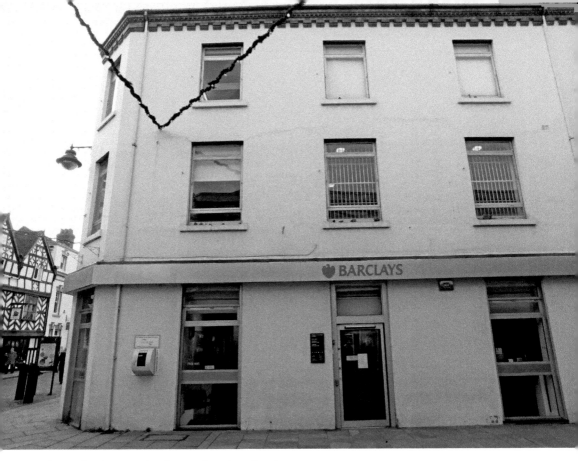

Once the Goat's Head, now Barclays Bank.

The Goat's Head was not one of Lichfield's coaching inns but by 1879 was advertised thus in the *Lichfield Mercury*: 'The Goat's Head, Family and Commercial Inn, Market Place. Visitors to Lichfield can be supplied with dinners, teas, chops, steaks, etc. Good Stabling. Open every morning at six. G. Hanson, proprietor.' Visitors were no doubt impressed with the pubs eight bedrooms and upstairs dining and function rooms.

By the early twentieth century the owner of the Goat's Head, William Robinson, also ran cabs and a furniture removal business with 'reliable horses and up to date vans to execute removals of furniture at most reasonable charges.'

This business was not without its pitfalls, however. In 1901 one of the Goat's Head's cab drivers (often used to run guests to and from Lichfield's Trent Valley Station) was fined 10s plus court costs for 'overdriving' one horse and beating another. In 1903 two other drivers working for the pub were fined at the local police court for embezzling 10s from Mr Robinson. In 1904 yet another driver was fined 6s for being asleep in charge of a horse and trap in St John Street.

The Goat's Head remained a popular pub and meeting place well into the twentieth century, the regular venue for gatherings of the Lichfield Cycling Club and for rugby club and local railway employees' dinners. At one time it boasted the largest snooker table anywhere in Lichfield.

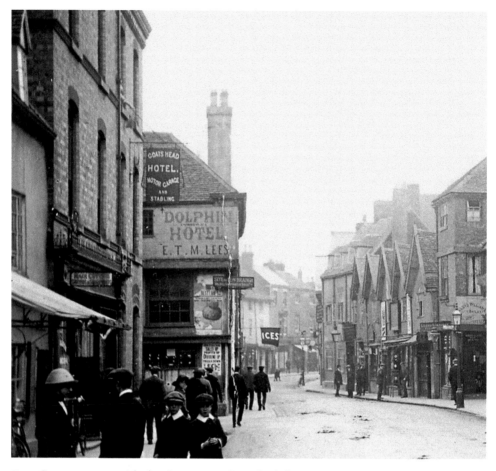

Bore Street *c.*1912 with the Goat's Head on the left.

The last landlord of the Goat's Head was Horace Wilson who was landlord from 1958 until the pub finally closed its doors for good on 9 January 1970. Mr Wilson had been the licensee of three other public houses in the city and had been the first landlord of the Anglesey Arms when it opened in Curborough Road in 1938. Horace Wilson had actually been born and raised in a Lichfield pub; his grandfather, W. N. Hyde, had been licensee of the Royal Oak on the Walsall Road for many years.

A regular at the Goat's Head, Fred Matthews, aged sixty-five, told the *Lichfield Mercury*, on the day the pub closed that he remembered a number of characters that could be found in the pub in the 'old days', one of whom was a Mrs Lyon, who was 6 feet tall and could easily carry 'a large sack of taters under her arm'.

8. MALT SHOVEL, Conduit Street (c. 1592–1971)

The Malt Shovel Hotel dated back, at least, to 1592 according to an old title deed. The pub stood at No. 20 Conduit Street (originally Butcher Row) opposite the Market Place and is now a Fatface clothes store.

In 1851 the owner and licensee of the Malt Shovel was Jeremiah Holdcroft who was born in 1816 in the nearby village of Hints. He resided at the pub with his wife Sarah, three children, three servants and one 'inmate,' forty-nine-year-old Matthew Bennett, who was described as a dancing master. Holdcroft was succeeded as owner by John Tricklebank, who sold the pub to the Lichfield Brewery Co. in 1878.

The Malt Shovel was a popular venue in the 1880s with organisations like the Licensed Victuallers' Association, which held its annual dinner there in October 1888 and where 'sixty sat down to a meal provided by landlord William Bakewell'. Bakewell died in 1892 and it was his wife Mary, another example of a determined woman running a pub business, who took over as licensee and remained there until 1901.

In the 1930s, mainly because of its close proximity to the Market Place, the Malt Shovel had a close relationship with the new breed of motor-coach drivers, who would pick up and drop passengers there. For example in January 1935 a dinner was held at the Malt Shovel for seventy-two drivers and proprietors of motor coaches and charabancs. Cllr Collins, who gave a speech at the dinner, mentioned one of the problems with the Market Place's use as a bus depot when he highlighted the difficulties ladies in high-heeled shoes had when they attempted to walk across its cobbled surface.

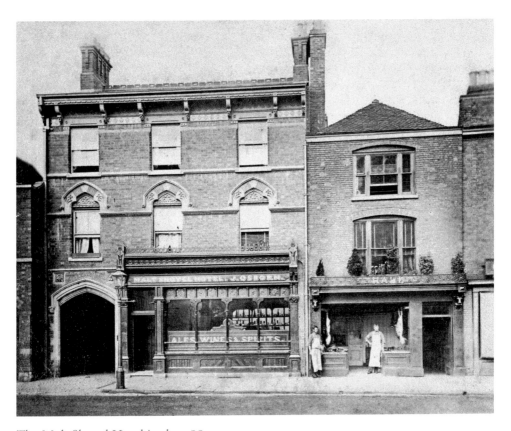

The Malt Shovel Hotel in the 1880s.

In later years the Malt Shovel tried hard to keep up with the latest trends and endeavoured to be a popular pub with the younger people of the city. In 1969, for example, regular Wednesday night 'discotheques' were held at the pub with an admission price of 3s.

It was to no avail. After its long history the Malt Shovel became another in the extensive and sad list of the city's ex-pubs when it closed in October 1971 and became a shop the following year.

9. OLD CROWN, Bore Street (pre-1722–1983)

The Old Crown was a fine old coaching inn, which stood in the site now occupied by Boots opticians at the bottom of the present shopping precinct.

The earliest actual mention of the pub was in the *Birmingham Gazette* of February 1771, although M. W. Greenslade has written that the pub existed in 1722. By 1789 it had become a regular meeting place of the Lichfield Turnpike Trust whose members included Erasmus Darwin, General William Dyott and Canon Seward, the father of Lichfield poet Anna Seward. In 1864 Joseph Trevor became the landlord of the Old Crown and later also became sherriff and mayor of Lichfield. In 1867 he moved to the Swan Hotel where he was in charge for many years.

The Old Crown possessed a number of low-ceilinged rooms, the most prominent of these being the upstairs Market Room, a venue where gatherings of local farmers and traders would discuss commodity prices and conduct deals.

Like many other Lichfield pubs, in the years before the First World War, a number of inquests were held at the Old Crown including one that looked into the death of its own landlord in September 1884. John Peattie died when he was thrown from his trap in Whittington with the inquest concluding that his skittish horse had shied and tipped

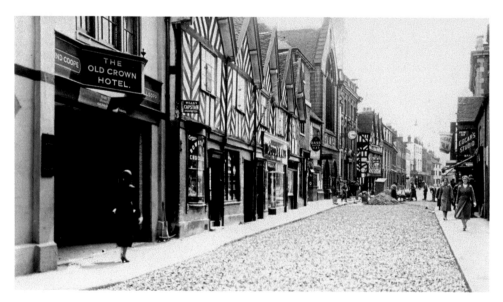

The Old Crown Hotel *c.* 1940s.

over the two-wheeled dogcart. Incidentally, there was some discussion at the time in the city's local press as to whether or not, when inquests were held at pubs, the body of the deceased person should be on display during the proceedings. One imagines that the risk of cross-infection in places where food and drink was served was quite high but the practice continued well into the twentieth century.

Happier gatherings also took place at the Old Crown as the pub became a regular venue for annual dinners including that of the Lichfield Police, the Bell Ringers' Society and the local Licensed Victuallers' Association. The Old Crown had many other attractions too, for example, an advertisement in the *Lichfield Mercury* in June 1891 extolled the pub's 'well-appointed billiard room with one of Burroughs and Watts celebrated tables boasting patent new cushions'.

In more recent times the Old Crown was the scene of a highly popular weekly folk club where in the 1960s and 1970s many performers who later on became famous, such as Jake Thackray and Jasper Carrot, made successful appearances.

The Old Crown closed in April 1983, and despite being a grade II listed building, 'fell down' during rebuilding and was subsequently demolished in November of that year, a turn of events that the *Lichfield Mercury* of the time suggested was not without a degree of controversy. Whatever the cause of its disappearance the pub was replaced with nondescript newly built shops and Lichfield had lost yet another of its old, historic and popular pubs.

10. PRINCE OF WALES, Bore Street (pre-1818–*c.* 2004)

The Prince of Wales was situated at the end of Bore Street. Sadly this once bustling pub has been derelict and boarded up for a number of years. Known as the Queen's Head in 1818

The now derelict Prince of Wales on Bore Street.

and the Turf Tavern by the 1840s, it became the Prince of Wales in 1868 when it was taken over by the Ffrench family. In more recent times it suffered a series of non-traditional name changes – Pipers, Chameleon and the Feria – before finally closing its doors.

11. SCOTT ARMS, Dam Street (1830s)

The Scott Arms was mentioned in the *Lichfield Mercury* in February 1833 in relation to a ball at the guildhall given in honour of local MP Sir E. D. Scott who owned the pub and from which tickets to the ball could be purchased. The *Lichfield Mercury* of 18 January 1833 had previously reported that fifty city public houses hosted dinners to celebrate Scott with 'the best English fare, roast beef and plum pudding in abundance'. It has to be said that it is difficult to imagine a similar honouring of a parliamentary representative today!

Sir Edward Dolman Scott was a Whig politician and MP for Lichfield from 1831 to 1837. He had succeeded to the Baronetcy and Great Barr Hall in 1828. Little more is known about the pub that carried his name and which seems to have closed at the end of his period in Parliament.

12. THREE CROWNS, Breadmarket Street (pre-1769–c. 1960s)

One of the great historic pubs of Lichfield is also sadly no longer with us. The Three Crowns stood in Breadmarket Street, opposite the Market Place and next to

The ex-Three Crowns.

Samuel Johnson's house. After Johnson had left his home city to move to London, and when he returned to Lichfield for visits, he always made a point of staying at the Three Crowns. In 1776 he brought his biographer, James Boswell, with him and both men stayed at the inn because, according to Boswell, Johnson liked Joseph Wilkins the landlord. There the two had 'a comfortable little supper' and drank a lot of Lichfield Ale. Boswell found the two-bedded room he and Johnson stayed in 'only tolerable', but seemed to appreciate the Staffordshire oatcakes which he was served for breakfast. Boswell also recorded in his journal that the people of Lichfield were 'the most sober, decent people in England'.

Despite this sanguine and understandably biased view of Lichfield folk, it was also true that crimes of various types seemed to be quite common at the time. In August 1769, for example, Three Crowns' landlord, Joseph Wilkins, posted a reward of five guineas in the *Birmingham Gazette* for the return of his horse, which had been stolen from a field adjoining the inn.

According to Samuel Johnson the Three Crowns performed another valuable service to the local community as well as selling beer and victuals. By 1775 the pub was the headquarters of the Lichfield Amicable Society. The society ran 'Box Clubs' where members saved 2 pence each week and then were able to claim 6 shillings a week when in need of financial help. Lichfield at the time seemed to be a centre for Friendly Societies, a large number of which started up in the city during the eighteenth century.

Between 1793 and 1859 the Cato family ran the Three Crowns. Until 1835 the landlord was Joseph Cato, who had fought in the French Army against the British and had originally arrived in Lichfield as a prisoner of war. After the fighting he decided to stay in the city and became a much respected landlord and founder of the Lichfield branch of the Cato family, his son John Joseph Cato taking over from him as publican.

An interesting auction took place at the Three Crowns in 1832 when auctioneer Mr Harris,put up for sale the house that Samuel Johnson had been born in. For many years the building was not open to the public but thankfully today Johnson's house has been restored and is now the excellent Johnson Birthplace Museum. Close by, in the Market Place, are statues of both Johnson and Boswell.

The Three Crowns Inn became a thriving establishment throughout the nineteenth century, advertising itself in 1887 as having 'Good stabling, well-aired beds [and] dinners, teas and suppers provided upon the shortest notice.' It was also the regular meeting place of a number of groups such as the St Cecilia music society and, in the 1890s, the Lichfield Cycling Club, whose chairman had the delightful name of Mr E. M. Tingle.

A low point for the Inn came in March 1904 when the landlord, the equally interestingly named, Charles Tipler, was found guilty of allowing the inn to become 'the resort of reputed prostitutes on divers dates'. Tipler was fined £10 plus costs and magistrates charged the owners, the Lichfield Brewery Company, with ensuring that the pub was strictly conducted in the future.

Uniquely perhaps the Three Crowns had the great distinction of having famous people born in adjoining buildings on both sides. Samuel Johnson, of course, was born on one side and on the other was the birthplace of Elias Ashmole, astronomer, astrologer and art collector, whose name is perpetuated in the Ashmolean Museum in Oxford.

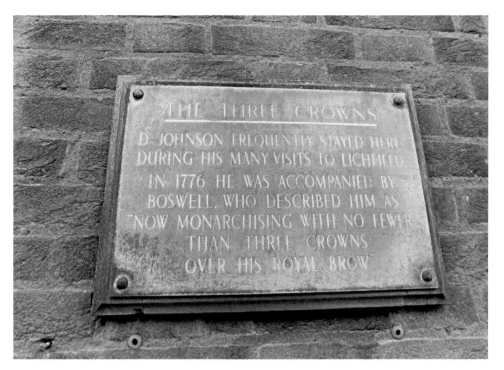

The plaque informing passers-by about the Three Crowns.

Unfortunately the rich history of the Three Crowns did not save it from closure in the 1960s. Today, although the building still exists, only a plaque on the wall is there to show how important the inn was in times past.

13. WINDSOR CASTLE, Dam Street (pre-1818–1930)

The Windsor Castle Inn stood at No. 16 Dam Street. Dating from before 1818, it may have previously been known as the Red Lion.

The Windsor Castle's landlord in 1851 was Mark Redfern, who described himself as a painter and victualler. This tradition of having two roles seems to have been perpetuated as Harry Harrison, landlord in 1911, was also described as a painter in the census of that year. Perhaps the two jobs were more than Mr Harrison was able to cope with as in May 1911 he was fined £2 plus costs for allowing drunkenness on his licensed premises. The drunks in question happened to be Harrison's wife Fanny and his father-in-law William Young, described in court as being 'fighting drunk', both of whom were also fined. The Harrisons left the pub later that year.

In 1930 the Licensing Magistrates decided not to renew the Windsor Castle's licence after deciding that the building was no longer suitable for use as a public house as some of its rooms were in poor condition. The pub was subsequently closed and compensation of £1,250 was later paid to its owners.

Today the Windsor Castle is a private residence; local stonemasons Bridgemans added ornate first-floor windows in the mid-1930s.

The Windsor Castle in Dam Street, now a private house.

14. WOOLPACK, Bore Street (pre-1793–1904)

The Woolpack, situated at No. 23 Bore Street, was first mentioned in 1793 and carried on trading until 1904 when its license expired under new licensing regulations brought in, mainly, to cut down the number of pubs and curb the amount of drunken behaviour. The building was taken over by Salloway's jewellery shop, which remains there to this day.

The ex-Woolpack.

Chapter Two

Tamworth Street and Greenhill

At one time there were many pubs in this area of the city. Over the years, mainly due to new stricter licensing laws as well as the economics of the pub trade, most have disappeared. Perhaps because of the number of drinking establishments, the area was renowned, in the nineteenth and early twentieth centuries, for being poorly behaved and, at times, violent. Indeed in Victorian times, according to 1930s local historian, J.W. Jackson, regular unofficial and unlicensed prize-fights used to take place in a cul-de-sac on the north side of Greenhill. One of these was between 'Doggie' Morris of Greenhill and Charles North 'the famous Nottingham boxer' which 'Doggie' apparently won. Thankfully those days have gone and the pubs that are left are very peaceable, pleasant and friendly establishments.

15. PIG & TRUFFLE formerly the ACORN INN, Tamworth Street (pre-1800–present)

The Pig & Truffle stands at No. 18 Tamworth Street but until 1988 the pub was known as the Acorn, and was in existence for well over 200 years.

In 1818 the licensee was Ellen Webb, another of the many independent females in charge of Lichfield pubs at a time when opportunities for women to run businesses were severely limited. However, another female licensee, Sarah Jennings, was brought to trial in 1890 for 'serving during prohibited hours', but the court believed her when she testified that she had misunderstood the complicated licensing hours of the time and only fined her court costs of 8 shillings.

In 1851 the landlord at the time, William Slater, who described himself as a licensed victualler and journeyman wheelwright, was prosperous enough to employ at least one servant. Like a number of other pubs in Lichfield, a horse-drawn cab service was provided by the inn in the latter part of the nineteenth and early twentieth centuries; the 1901 census showed that an ostler, Octavius Parker, was employed there.

Like a number of old Lichfield pubs, the Acorn, as it was at the time, claimed to have a resident ghost. In December 1972 barmaid Thelma Wall related her experience to the *Lichfield Mercury*. She had, apparently, gone to serve a man dressed entirely in black standing at the bar who promptly disappeared before her eyes. Unnerved by the

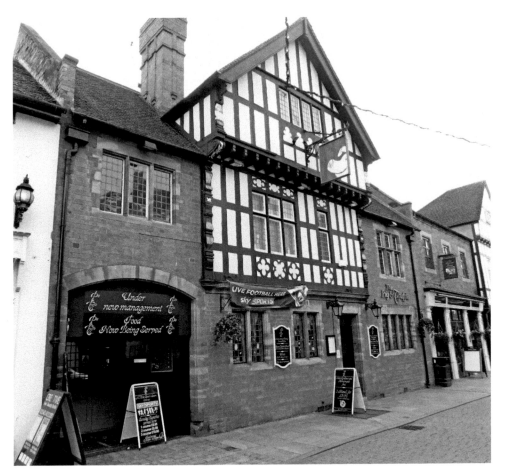

The Pig & Truffle, formerly the Acorn.

experience she told the landlord, Les Hine, who informed her that many regulars had seen the spectre over the years, so much so that they had christened it Fred. According to the landlord Fred could often be seen sitting in the corner reading a newspaper. Mr Hine told the local paper that 'we were all quite nervous about 'Fred' at first but we have now come to know him. Mind you he can be mischievous. He has thrown glasses at my employees and he has thrown my breakfast at me before now!'

Despite the capricious ghost the pub was well run and tranquil enough throughout the nineteenth and twentieth centuries and remains today a popular public house in an area of the city that boasts three pubs in a row.

Next to the Pig & Truffle is the present-day Acorn, a very popular and well-used pub and a typical example of a J. D. Wetherspoon's public house. It is to that company's credit that the traditional 'Acorn' name was revived when the pub was opened in the 1990s.

Next to the Acorn Inn is the Crown, another popular chain pub opened in the 1990s, and it too has resurrected the traditional name of an old, lamented Lichfield establishment.

Inside the Pig & Truffle.

J.D. Wetherspoon's the Acorn Inn.

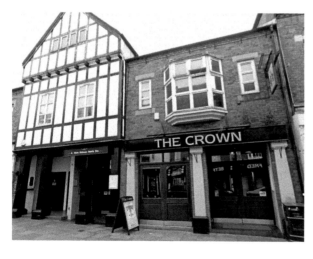

The Crown on Tamworth Street.

16. DUKE OF YORK, Greenhill (c. 1600–present)

The Duke of York sits at the top of Greenhill facing St Michael's evocative church and churchyard. Its name is said to derive from the Duke of York who eventually became James II in 1685.

The Duke of York is one of the oldest pubs in Lichfield with its origins obscured by time, although it's quite possible that an inn has been on the site since the fourteenth century. Its status was acknowledged for many years in Lichfield's annual Whitsuntide Greenhill Bower when great quantities of meat would be roasted outside the pub for Lichfield folk to feast upon.

In the 1830s and 1840s the pub's landlord was Thomas Haywood. He, like many other innkeepers of the period, described himself as a brewer and reminds us of the

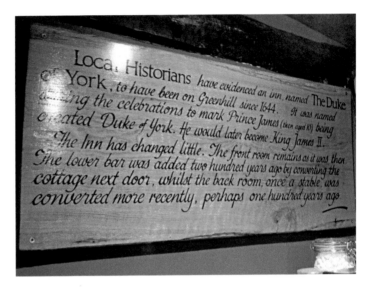

Perhaps the oldest pub in Lichfield.

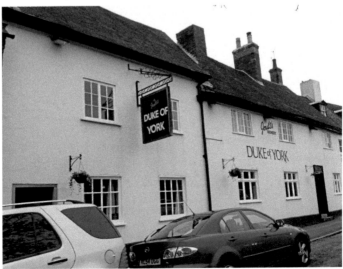

The Duke of York.

time when most public houses produced their own beer with ingredients provided by maltsters, there being some nineteen of these in Lichfield in 1842.

Harry Cresswell, who was the licensee from 1915 to 1939, was another who had more than one job; he was Lichfield's Chief Fire Officer. Mr Cresswell was also one of a number of landlords who temporarily transferred the pub licence to their wives when they themselves were called-up in 1916 to fight in the First World War.

It is hard to credit these days how rough and sometimes how violent the Greenhill part of the city was in past. Then the Duke of York was one of many pubs in a relatively small area with numerous old, small and overcrowded houses alongside some warren-like dark alleyways and Greenhill was the scene of a number of riotous events with drunkenness leading to regular violence. For example, in March 1877, labourer John Baker was found guilty of being drunk, disorderly and assaulting a policeman. In November 1878 three labourers working on the building of Whittington Barracks were charged with being 'drunk and riotous' and one of them with assaulting a police officer. It was found that they had been drinking at the Duke of York and the nearby Waggon and Horses.

There were many other such incidents at the time but perhaps the worst case took place in June 1902 when 'riotous behaviour of the type seldom seen in Lichfield' took place in an alleyway on Greenhill known as 'the gullet'. When the police attempted to arrest a man called Russell a crowd 'some hundreds strong' turned on the police and many of the attending constables were 'knocked about'. Five men and one woman were subsequently arrested and all appeared in the police court the following morning. The offenders were given prison sentences, in some cases with hard labour.

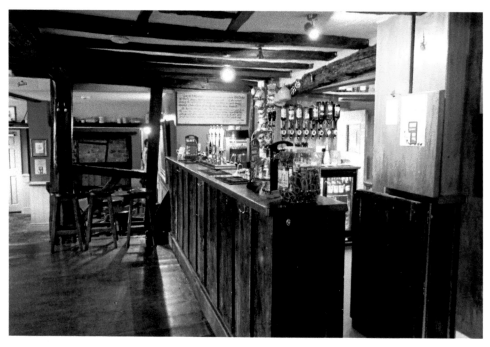

Ancient beams in the bar of the Duke of York.

It is interesting to note how at this time, in the last quarter of the nineteenth century, a small number of locals made many regular appearances in Lichfield's court and also in the pages of the local newspaper, the *Lichfield Mercury*. One such person was Sarah Thacker who was born in 1855 in Lichfield and was described by the police as 'a notorious character'. By 1894 Sarah had made fifty-seven appearances in court for drunken behaviour and, because she rarely had any money to pay her fines, had served many prison sentences, often with hard labour. On one occasion, when magistrates gave her the choice of a 5s fine or fourteen days in gaol, she plaintively replied, 'I shall have to go to gaol for mine, sir, without you'll let me have to Saturday.' Sarah Thacker died in 1897 aged forty-two, almost certainly from liver disease, and was buried in St Michael's churchyard.

Today the popular, but now very peaceable, Duke of York remains a firm favourite with Lichfeldians and visitors to the city, renowned for its lunchtime bar food and its excellently kept ales. Owned by Joules Brewery of Market Drayton, it is one of the most historic and cherished public houses in the city and it is always a pleasure to spend time there.

17. WHIPPET INN, Tamworth Street (2014–present)

The first micropub in Lichfield, and the only pub in Lichfield named after a 'Carry On' film innuendo, the Whippet Inn stands at No. 21 Tamworth Street next to the disused and sadly neglected Regal cinema.

The pub opened in 2014 and is run by the enthusiastic Paul Hudson and Debbie Henderson. Serving well-chosen beer and cider from independent brewers, in a small one-roomed establishment previously used as a ladies' clothes shop, the very popular micropub is a return to the old idea of the simple beerhouse.

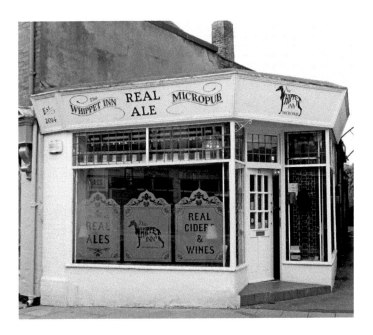

The Whippet Inn.

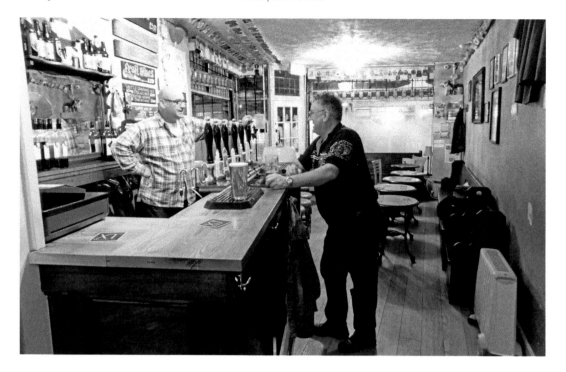

The interior of Lichfield's first micropub.

Interestingly the Whippet Inn is on the same site as a similar beerhouse that existed from the early 1860s until 1904. The pub was then called the Grapes and was a larger building than exists today, standing at Nos 21 and 23 Tamworth Street. The pub's first licensee was Ann Hitchins, but from 1889 the pub was run by her grandson John Abdella (sometimes spelt Abdellah) who, as well as being described as a beer retailer, was also a hairdresser. Abdella's barber's shop was situated in an adjoining room to his pub. This caused problems as the city's licensing authorities did not like two businesses being in such close proximity and the renewal of the license was queried in 1890.

When the Grapes did eventually close in 1904 Abdella moved his hairdressing business across the road to No. 24 Tamworth Street where he continued to conduct his non-beer business until the 1940s.

Next to the Whippet Inn stands another very recently opened, small continental-style café/bar called Beerbohms. Whether this trend for small niche pubs continues into the future will be watched in the city with interest.

These two new pubs have at least in a small way replaced some of this area's lost public houses. These include:

18. BALD BUCK, Greenhill (pre-1770–2010)

The Bald Buck, in two incarnations, used to stand at the top of the Greenhill in Tamworth Street. The original pub building was first mentioned in 1770 when Samuel Cadman was the landlord. In 1818 the publican of the Bald Buck was Edward Maddox

who was, in the census of 1841, also described as a gardener. The Maddox family, in fact, ran the pub until the 1860s.

As we have already seen in the nineteenth century violent affrays and disturbances were all too common a feature of Greenhill and its pubs. For example in August 1883 Richard Fisher, a bricklayer, was found guilty of assaulting Joseph Smith, a tinman of Rotten Row, while in the Bald Buck. He refused to pay a fine and so was sent to Stafford gaol for one month.

A more light-hearted incident took place in July 1891 when the landlord, Frederick Sedgwick, was unsuccessfully sued by James Ashley for damage caused to his fence and garden – by an elephant! This arose after the manager of a 'Wild Beast Show', which was visiting Lichfield, had arranged with Sedgwick for his elephant to be kept in the Bald Buck's stable overnight. During the night the tether securing the elephant had worked loose and the elephant escaped and proceeded to galumph through Mr Ashley's garden. At the trial the judge ruled that because the elephant's owner was supposed to ensure that the animal was properly tethered, the pub's landlord could not be held liable for the damage.

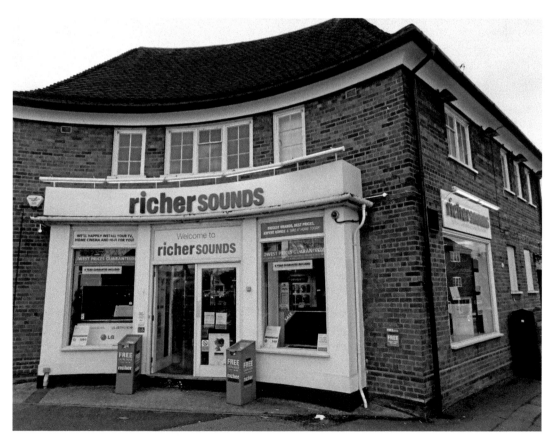

The ex-Bald Buck public house

The old Bald Buck was demolished to make way for the building of the new Birmingham Road and the new pub rebuilt in a different position. Interestingly workmaen demolishing the pub discovered an ancient well beneath the foundations of the building. Experts agreed that the well would have been in existence before the original Bald Buck had been built some 300 years before.

The new pub opened on 15 August 1957. It was built by J. R. Deacon Ltd of Lichfield and was described at the time as 'a first-class modern public house incorporating the very latest features and workmanship'. It boasted a large bar, a market room for the use of farmers attending the nearby cattle market and a gentleman's smoke room. However, the pub closed down in 2010 and Richer Sounds electrical store and a takeaway pizza outlet currently occupy the building.

19. BLUEBELL, Rotten Row (pre-1851–1982)

A short walk across the road from the Bald Buck, at No. 49 Rotten Row, stood the Bluebell (sometimes called the Blue Bells Inn).

First mentioned in 1851 when the landlord was Joseph Allton, the pub became a favourite stopping-off place for soldiers, particularly after Whittington Barracks was built in the last part of the nineteenth century.

In April 1886 three soldiers from the North Staffordshire regiment were charged with raping a woman they met at the Bluebell. They had followed her out of the pub after she had been ejected by the landlord for drunken behaviour and had dragged her down a 'lonely lane' where she was 'outraged' by all three. According to the _Lichfield Mercury_ her terrified screams were heard for twenty minutes, during which time she was also kicked and punched and had a handkerchief shoved in her mouth. People who had heard her screams eventually answered her distressed calls and the three soldiers were later identified by witnesses and charged.

The Bluebell, like many pubs in the city, was also the venue for inquests into tragic deaths, including that of the wife of landlord George Dean in January 1891. Seventy -year-old Eliza Dean had fallen to her death down the cellar stairs but the coroner was quick to point out that she was neither drunk, nor the victim of foul play.

Another inquest took place in April 1900 when the city coroner examined the cause of death of seventeen-year-old William Hewitt of Dean's Croft, killed while driving a horse and trap in Station Road. The deceased youth had been employed by another Lichfield pub, the Robin Hood, and had died after he had been thrown out of his vehicle when his horse had shied after being startled by a train whistle. Hewitt had subsequently hit his head on the station wall and the coroner, who said the wall was at a dangerous height, was able to recommend to the North Western Railway that they should build it higher to avoid similar accidents in the future.

The Bluebell eventually closed in 1982 when it became a council-run refuge for young homeless people called Bluebell House. At the time of writing the refuge, which provided security for sixteen- to twenty-five-year-olds and is now called the Lichfield Foyer, is due to close, according to the _Lichfield Mercury_, after Staffordshire County Council withdrew its funding.

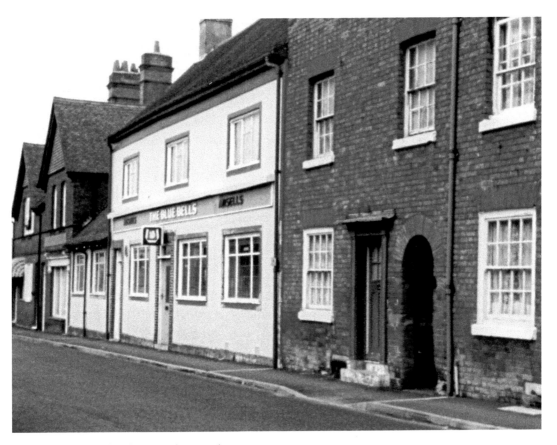

The Blue Bell pub, just after its closure.

20. BLUE BOAR, Church Street (pre-1800–1878)

The Blue Boar was a beerhouse situated, at the time, near to many other Greenhill public houses.

The pub has been primarily remembered for having a cockpit and was the scene of regular cockfighting events, these being particularly popular during Lichfield race weeks. The Swan Hotel also had a cockpit where 'mains' of cocks were regularly fought, the last recorded such event in Lichfield taking place as late as 1877.

By 1871 the pub was known as the Blue Pig but the new name was short-lived as in 1878 the pub became the Working Men's Coffee House. This new venture was established by the Revd J. J. Serjeantson of St Michael's as an alternative to what he saw as the deleterious effect of the number of public houses in the Greenhill area. The *Lichfield Mercury* opined that the Blue Pig had been 'second-rate' and the new coffee house 'has a comfortable appearance' and was a great contrast to it. The newspaper went on to advise the wives of working-class men to persuade their husbands to go to the coffee house saying that 'it will be a means of pleasure to them and of happiness to you'.

21. BULL'S HEAD, Tamworth Street (1810–1911)

The Bull's Head stood at No. 71 Tamworth Street in a building that was later known as the Greenhill Chippy and was directly opposite the Holly Bush Inn (now a Chinese restaurant).

The first listed landlord was Phillip Salt in 1810 and he was succeeded by James Dabbs who ran the pub until the 1850s. Dabbs, born in 1789, was also in charge of the Holly Bush in 1851. The only other person living at the Bulls Head at the time was a servant, forty-year-old widow Catherine James.

Like so many other pubs in the city, the Bulls Head was a regular venue for inquests. One held in July 1888 looked into the mysterious death of a young woman, nineteen-year-old Emma Jane Mills. She had lived at the Windsor Castle public house in Dam Street and had been discovered dead and unclothed on the bed of a city man called Henry Russell. Mr Russell told the inquest that Emma had asked to lie down after eating a meal of rabbit, peas and stout and he had later discovered her on the bed seemingly not breathing. A doctor who pronounced her dead told the coroner that there were no signs of violence on the woman's body. Two rings Miss Mills had been wearing had been removed from her fingers, however. After a long deliberation the jury reached the verdict that the deceased had died 'by a visitation from God' and by 'spasms and the failure of the heart'.

The position of the Bull's Head near to the notoriously violent Greenhill area lead to various other, more explicable, instances of violence. In October 1883 a 'savage

Until 1911 this building housed the Bull's Head pub.

assault on the police' took place when William Coderel, a private in the North Staffs regiment, had set about the landlord, Mr Harwood, and PC Martin in a 'savage manner'. Unable to pay the hefty £5, fine the hapless soldier was given a month in gaol with hard labour.

In July 1885 another assault on a policeman by a soldier took place at the pub when James Rooney, also a private in the North Staffs regiment, punched PC Robinson while 'under the influence of drink'. The punishment in his case was a £20 fine or three months in prison.

The Bull's Head's reputation for poor behaviour carried on into the twentieth century. In January 1901 George Burton was found guilty of assaulting Mary Whitehouse, a servant at the pub, and using 'very bad language'. He was fined £1 for the assault (obviously assaulting a woman was not considered as serious as assaulting a police officer) and one shilling for using bad language. In September 1904 Thomas Smallwood, a 'tattooer from Birmingham', was fined for throwing a brick through one of the pub's windows after being ejected for drunk and disorderly behaviour.

In the light of such antisocial behaviour it is perhaps not surprising that the Bull's Head had closed down by 1911.

22. COACHMAKER'S ARMS, Tamworth Street (1828–1848)

The Coachmaker's Arm was a short-lived beerhouse that stood next to the present-day Lichfield Methodist Church.

The only listed landlord was John Heap and the pub's name reminds us of the time when hostelries were often named to reflect the main occupation of the proprietor, the Heap family having a coach-making business which continued after the pub closed down in 1848.

23. CURRIER'S ARMS, Church Street (1841–1861)

The Currier's Arms, situated on Greenhill at No. 7 Church Street, is another example of a pub named for the occupation of the landlord. On the census returns for the relatively short time the pub operated, the licensee, John Smith, described himself as an innkeeper and a currier (a leather worker).

24. GOLDEN BALL, Tamworth Street (pre-1822–1904)

The Golden Ball stood at Nos 35 and 37 Tamworth Street. In 1822 the landlord was Edward Lester and the pub was known as the Old Golden Ball, suggesting that it had been there for some time.

Like many other pubs in the Greenhill area the Golden Ball had a poor reputation. In June 1883 magistrates fined the licensee, Martha Bailey, for selling beer in prohibited hours and for keeping 'a disorderly house'. In March 1892 Clara Sheldon, from Walsall, was sent to gaol for fourteen days for her drunken behaviour in the pub. And in September 1896 the landlady's husband, James Dickenson, who was also the pub's piano player, received a warning for threatening his wife and daughter with a knife (such domestic offences did not seem to be taken too seriously in those days). In March 1898 PC Williams was awarded a bonus of 10s for 'his smartness' in arresting an army

deserter at the Golden Ball. He may not have needed to have been too smart – the deserter had gone into the pub disguised as 'a negro who could not speak English'.

In June 1901, partly perhaps because of its reputation, the owners of the Golden Ball, the City Brewery Co., changed the pub's name to the Saddler's Arms. It was to no avail. New licensing regulations, brought in by the government in order to crack down on drunkenness across the country, forced the pub to close its doors forever in 1904.

25. GRESLEY ARMS, Gresley Row (pre-1818–1930)

The Three Spires loading area marks the spot where the Gresley Arms once stood. In 1818 the licensee was Arthur Rowley and the final landlord was the magnificently monikered Fleetwood Rockingham.

In 1878 the pub was the venue of a tragic and fatal shooting. On Guy Fawkes' night the landlord, William Green, decided to play a practical joke on the customers in his pub by discharging an old gun loaded with gunpowder and paper. Unfortunately a marble was lodged in the barrel of the gun and when it was fired Samuel Bates, a Walsall man sitting having a quiet drink with friends, was hit in the head and died instantly. The inquest, which was also held at the Gresley Arms, was told that Green had borrowed the gun from his next-door neighbour, Henry Styche. Styche, in what was described at the time as a 'barely intelligible' testimony, swore that he did not know how the marble had found its way into his gun. The inquest's verdict was that of accidental death but the coroner strongly implied in his summing up that he had not totally believed Styche's evidence.

However, the pub continued to be a popular meeting place and hosted a number of get-togethers by various organisations, such as the annual dinner of Lichfield's railway employees in January 1895, where the toast was 'Success to the London and North-Western Railway Company and its employees.'

The pub closed in 1930 on the grounds of redundancy, the licensing magistrates having decided that there were far too many public houses in the Greenhill area at the time. The compensation paid to the owners of the Gresley Arms, the Lichfield Brewery Co., was £1,725.

26. HOLLY BUSH, Tamworth Street (pre-1818–1988)

The Holly Bush stood at the top end of Tamworth Street and the building today is the Lee Gardens Chinese restaurant.

The first obvious mention of the pub was in 1818 when the licensee was Edward Maddox, a member of a family associated with a number of other city pubs. In 1878 the pub was rebuilt and the current building, apart from its usage, is more or less unchanged since then.

The Holly Bush, like so many of the Greenhill pubs, was, in the nineteenth century particularly, affected by drunken violence that tended to plague the area. In January 1894, for example, two brothers, Edward and John Smith, were found guilty of breaking glass panels in the pub and assaulting the landlord, Charles Smith, after he had asked them to leave his premises. In June 1888 the landlord at that time, William Linforth, was charged with assaulting his wife Alice as well as a man called Edward

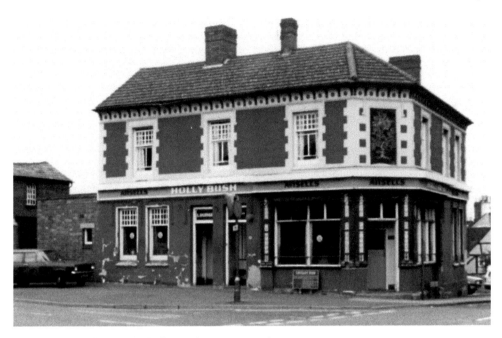

The Holly Bush shortly before it became Knights.

Treadgold, a bricklayer of Gresley Row. Magistrates fined Linforth £1, letting him off quite lightly as they said that he had been subject to extreme provocation.

Generally, however, the Holly Bush had a fairly uneventful history until the 1980s when it dropped its traditional name and became one of the new wave of 'fun pubs' apparently so popular at the time. Called Knights, it employed, for a short time, bar staff on roller skates for some inexplicable reason and then, in the late 1980s, it became a restaurant.

27. JOLLY GARDENERS, Greenhill (1851–c. 1870s)

The Jolly Gardeners stood at the top of Greenhill near to the Duke of York and the Spread Eagle, and next door to the Curriers Arms.

In 1851 the licensee was James Burton, born in 1818, who, as well as describing himself as a publican, was also the city's mace-bearer. The pub at the time was probably called the Fat Ox and only adopted the name Jolly Gardeners when the subsequent landlord, George Burton, who was a market gardener, took over the running of the pub. The last official mention of the pub seems to have been in 1871 when George Burton was still the licensee.

28. KING'S ARMS, Tamworth Street (pre-1793–1904)

The King's Arms was situated at the bottom of Tamworth Street. The frontage was rebuilt in the 1960s but the rear buildings still exist and have been the home of a number of different restaurants in recent times. The pub closed down in 1904 when new licensing regulations were brought in and the number of pubs in the city was drastically reduced.

The King's Arms dated back to at least 1793 when its landlord was Francis Smith. The pub's licensee in 1851 was James Gee who, in the census of that year, described himself as a victualler and tailor.

In a fairly uneventful history the one very nasty incident connected with the pub happened in October 1888 and involved the seventeen-year-old daughter of landlady Mary Ann Thompson. While the girl was crossing the Bowling Green Fields she was assaulted by a man called Arthur Fox who flung her to the ground, held her there for fifteen minutes and struck her several times before she was able to escape. Fox also went on to assault another young woman, Elizabeth Lakin, a servant who worked at another Lichfield pub, the Rose and Crown Inn in Bird Street. Fox was arrested soon after the attacks and amazingly received just a two-month prison sentence. Chillingly, the same edition of the *Lichfield Mercury* that documented these Lichfield assaults also reported on horrific murders of women that had taken place in London's Whitechapel district – murders that would soon become known as the work of Jack the Ripper.

29. MITRE, Tamworth Street (pre-1818–1912)

The Mitre was another of the small Tamworth Street public houses that proliferated in the area until the early years of the twentieth century.

Like so many of the city's pubs the Mitre was the scene of inquests into the recently deceased. In April 1856, for example, Mr C. Simpson, the city coroner, investigated the death of William Mellor, a sixty-five-year-old plumber and glazier whose body had been found in a pigsty belonging to a lock house on the Birmingham canal. His son, Samuel Mellor, landlord of the Lord Rodney in Wade Street, gave evidence that his father had disappeared after getting drunk at the Woolpack in Bore Street.

In November 1904 the Mitre was the subject of a 'betting raid', the upshot of which saw Thomas Bowdler, landlord of the pub, along with a number of other men, charged with offences under the 1853 Betting Act. Bowdler was fined the significant amount, in 1904, of £25 while the others received lesser fines. Surprising perhaps, Bowdler was

The ex-Mitre public house.

allowed to keep his licence and was still in charge of the pub when it closed in 1912. Today, ironically, the building is home to an amusement and gambling arcade.

30. SMITHFIELD, Church Street (1868–2007)

In the days when a cattle market was situated where Tesco's Extra now stands, the Smithfield was a thriving pub that was particularly busy on sales and auction days.

Built in 1868 by the Lichfield Brewery Co., a short walk from the many other Greenhill pubs, its first landlord was John Owen, who also owned the George Hotel. In 1890 James Brinson took over the running of the Smithfield and posted an advert in the *Lichfield Mercury* which gives a flavour of what the pub was like, and also the language of the times:

> Smithfield Hotel. J. Brinson, proprietor, late of Silkmore Farm, Stafford. J.B. begs to inform the citizens of Lichfield that he has taken the above hotel and hopes that by strict attention to business and keeping wines, spirits, ales, etc. of the best quality to meet with a share of their patronage. N.B. Hot luncheons every sale day.

Unfortunately Mr Brinson did not have long to provide a service to his customers as he died just four years later at the age of sixty-eight, his wife Mary taking over the Smithfield until 1907.

The cattle market in Lichfield closed in 1988 when the owners Wintertons relocated to nearby Fradley. It went through a number of unnecessary name changes, including,

Outside the Smithfield Hotel, Bower Day 1897.

in 1995, being called the Three Golden Spires, before it closed and was finally demolished in 2007 as part of the expansion of Tesco's.

31. SPREAD EAGLE, Greenhill (pre-1833–c. 1930s)

The Spread Eagle stood next to the Duke of York. Today the building is a locksmith's shop.

It was first listed as a beerhouse in 1833 when the licensee was Thomas Thorneloe. The Thorneloes, in fact, ran the pub for much of the nineteenth century. John Thorneloe, who was the landlord until 1890, was described in 1861 as a victualler and collector of rates for the city.

Harry Jones, licensee in October 1895, was fined £5 plus costs for being drunk and disorderly and 'in a fighting mood' in Bore Street. Ejected from the George IV Inn and also found guilty of striking a man called Harris, Jones was, perhaps surprisingly, the secretary of the Lichfield Licensed Victuallers' Association and had run the Spread Eagle for five years, having had a previously unblemished record.

An unpleasant incident, all too common at the time in the Greenhill area, took place in July 1899 when George Wright assaulted Lily Wood in the passage of the Spread Eagle. According to the newspaper report at the time, Wright 'knocked her

The ex-Spread Eagle public house.

senseless' after she had been in the pub having 'twopenny worth of brandy' and the two had exchanged words and started fighting. Wright was fined just 5 shillings plus court costs.

32. WAGGON & HORSES, Greenhill (pre-1818–c. 1890s)

Another of the plethora of public houses that existed in the Greenhill area, the Waggon & Horses, stood on the corner of Tamworth Street and Gresley Row where a car park is now situated.

The pub seems to have been first mentioned in 1818 when its landlord was George Burton. The licensee in 1861 was Arthur Gee who described himself not only as a publican but as a clockmaker and journeyman too.

An advert for the pub in the local press in January 1865 shows some enviable pricing with bottles of claret and burgundy costing 1 shilling (5p); Champagne at two shillings and 8d (13p); gin at 1s and 11d (9p) and whisky at 2 shillings (10p).

In 1886 Frederick Cooper, a private in the North Staffordshire regiment stationed at Whittington Barracks, assaulted the then landlord Edward Briand. The soldier had attacked Mr Briand after the Waggon & Horses' landlord had attempted to stop Cooper stealing the pub's canary from its cage in the parlour. Cooper was fined 3 shillings. Briand was another of those Lichfield landlords who held down more than one job, describing himself in the 1881 census as a licensed victualler and a wheelwright.

The pub had closed by the turn of the century and the actual building was demolished in 1953 when the area and its roads were redeveloped.

Chapter Three

St John Street, Frog Lane, Wade Street and the Friary

At one time this area was replete with beerhouses, taverns and inns but today only three will be found. One is the Malt Bar which opened in 2012 and which is situated in Wade Street, close to the shopping precinct and opposite the Garrick Theatre. In a short time it has established a good reputation for real ale and good pub food in a modern, wine-bar-type setting. The other pubs in the area are far older:

33. BOWLING GREEN, The Friary (pre-1737–present)

There has been a bowling green and a pub of the same name next to it in Lichfield for centuries, although the immediate area surrounding both has changed drastically over time. Today the Bowling Green stands in the middle of a large and busy traffic island at the entrance to the city of Lichfield, at the confluence of roads leading to Birmingham, Walsall and Rugeley.

Bowls have been played on the site since the 1670s and the pub was first listed in 1737. An advertisement from June 1889 described the pub and its surroundings:

> This ancient and popular resort is now open for the season. The beautiful and spacious green has been carefully tended during the winter and will be found in grand condition for the pursuit of the favourite and healthful pastime of bowling. The gardens have been carefully laid out and present a most picturesque and attractive appearance. Every convenience for visitors: wines and spirits, ales and stout of the finest quality at moderate charges. Dinners, luncheon and teas provided at short notice. Proprietor: Chas Woodfield.

The total rebuilding of the pub started in 1929 when the whole area was redeveloped with the construction of the road through the Friary estate. The architect of the new Bowling Green, which was built in the mock-Tudor roadhouse style, was R. J. Barnes of Lichfield and the builder was J. R. Deakin of Lichfield and Walsall. The frontage of the new building faced southwest and there were large 'parking grounds' at the front and sides. The dining room and tearoom overlooked the actual bowling green and there was also a smoke room,

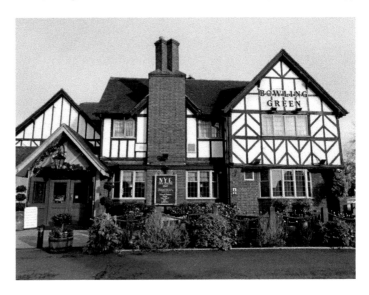

The Bowling Green.

bar and lounge. The clock tower, which had originally been sited in Bird Street facing the end of Bore Street, was moved and rebuilt in its present position at the rear of the pub.

The Bowling Green was popular in the 1950s, '60s and '70s as a venue for dinners, dances and wedding receptions. In 1983 it was revamped and became The Monterey Exchange, a cocktail bar and restaurant. Thankfully, however, the old name was reinstated in 1994 and today the Bowling Green remains a popular place for drinkers and diners, although to reach it as a pedestrian one has to take especial care when crossing the road to the pub.

34. GREYHOUND, St John Street (pre-1848–present)

Situated a short stroll from the City railway station, the Greyhound was first mentioned in 1848 as a beerhouse run by landlord William Marklew. Mr Marklew also owned a brick-making business and was licensee of the pub until 1884 when he died well into his eighties.

In October 1892, Sarah Foden, a young woman living in St John Street, was charged with stealing money from the Greyhound and starting a fire in one of the pub's bedrooms. Luckily the fire did little damage and Foden was committed to Stafford Assizes.

The publican in 1911 was unmarried Sydney Robert Ball, who was able to employ two servants – the wonderfully named Bertie Christmas, a pianist, and Sarah Ann Baker, a housekeeper. Although fined in 1914 for allowing gaming to take place in his pub, local magistrates allowed Sydney Ball to keep his licence.

The pub today is a popular venue that hosts regular live music events at the weekend and also incorporates an Indian takeaway.

The following pubs have now disappeared from this area:

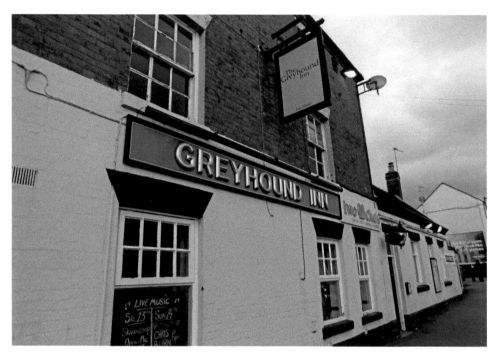

Above: The Greyhound Inn.

Below: The bar of the Greyhound.

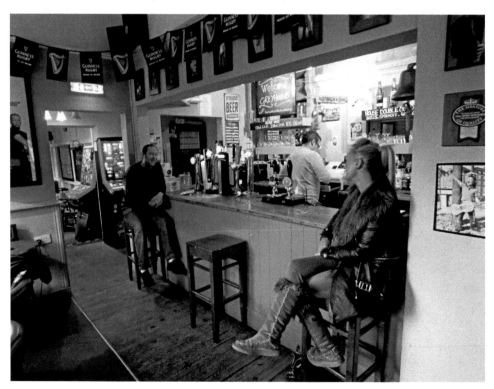

35. BEAR, St John Street (pre-1698–1820s)

The Bear was first mentioned in 1698 and was marked on maps in 1766. It stood in St John Street opposite the entrance to Throgmorton Street (now Frog Lane).

In the 1750s landlord Giles Tottingham ran a stage-wagon service to London from the pub. Called, somewhat erroneously, the Lichfield Flying Wagon, it took the best part of four days to complete the journey.

The Bear was demolished, or partially demolished, in the 1820s and in its place was built an imposing colonnaded town house called St John's House, still to be seen today.

36. BRIDGE TAVERN, St John Street (1861–1986)

The Bridge Tavern stood just the other side of the railway bridge in St John Street.

For many years the Gething family, who also owned a coal-merchant's business, ran the pub. Tragedy befell the Gethings in November 1883 when James, the son of landlady Ann Gething, and the manager of the coal business, was found hanging in the barn adjoining the pub. The body of the twenty-eight-year-old was found by a drayman employed by the Lichfield Brewery Co. across the street. An inquest into the death was held at the nearby Marquis of Anglesey Inn and heard that, according to his brother Walter, James Gething had recently 'been in low spirits'. The verdict was 'suicide while of unsound mind'. The family tragedy was further compounded when, in 1907, Walter shot and killed himself after spending some time in Burntwood 'lunatic asylum'.

The connection between the Bridge Tavern and the nearby Lichfield Brewery was a strong one and on many occasions the brewery draymen were treated to an annual dinner at the pub. In January 1904, for example, forty such draymen and waggoners sat down to 'an excellent repast' provided by landlord and landlady, Mr and Mrs Whatkiss.

In December 1976 the then landlord, Michael McAnulty, made an attempt to revitalise the pub when he persuaded the brewery to spend money on a new lounge.

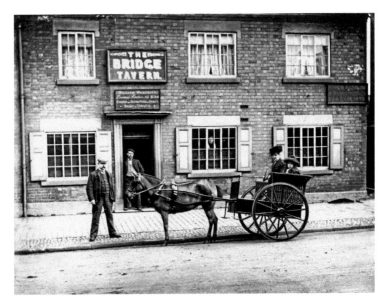

The Bridge Tavern
c. 1906.

Opened by the Mayor of Lichfield who said goodbye to the 'spit and sawdust' of the former room the new venture, complete with horse brasses and copper pots, was planned to introduce an 'olde worlde' atmosphere to the pub. (Interestingly workman rebuilding the lounge discovered an entrance to a tunnel that seemed to lead under the city.) However, the new-style lounge was to little avail and the pub closed in 1986. Recent attempts to reopen the Bridge Tavern have come to naught.

37. DUKE OF CAMBRIDGE, Wade Street (pre-1834–1926)

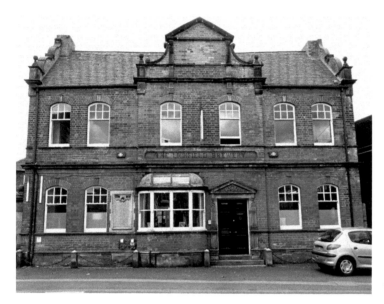

Once Lichfield Brewery's offices, opposite the Bridge Tavern.

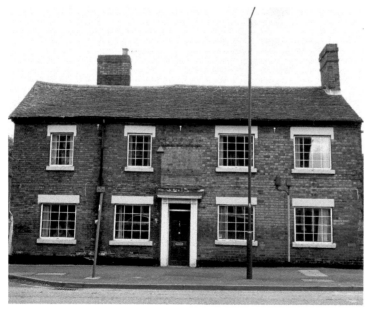

Now unfortunately closed, the Bridge Tavern.

The Duke of Cambridge was situated at No. 33 Wade Street and had a number of different names in the nineteenth century.

In 1834, when James Naden was the licensee, it was called the Tally-Ho; in 1835 it was referred to as the Fox and Hounds, with Thomas Buller as the landlord; by 1842 it had reverted to the Tally-Ho once more, before becoming the Hare and Hounds by 1860 and finally the Duke of Cambridge by 1865.

In the somewhat unruly atmosphere of Victorian Lichfield it appears to have acquired a poor reputation with local magistrates. For example, in April 1865 the landlord, Sampson Princep, was fined 5 shillings for allowing card playing in his pub and in the same week three men were caught fighting after falling out over a card game. In August 1883 landlord James Gumley was cautioned for allowing dancing in the Duke of Cambridge 'on many occasions'.

The pub, owned by the Lichfield Brewery Co. eventually closed down in December 1926 after licensing magistrates had decided that there were too many pubs in the immediate area.

38. HARTS HORN, St John Street (pre-1770–*c.* 1800)

According to John Shaw in his book *The Old Pubs of Lichfield*, the Harts Horn could well have been the oldest known inn in Lichfield.

It stood in St John Street next to St John's Hospital almshouses and was sited close to the south gate of the city, and so probably catered for travellers and pilgrims visiting Lichfield. In December 1770 the landlord, mentioned in *Aris's Birmingham Gazette*, was a Mr Twiss.

The Harts Horn was one of the inns of Lichfield, after 1789, along with the Old Crown, the George and the Swan, which became venues for meetings of the Lichfield Turnpike Trust that looked after the state of the roads around the city.

The inn was listed in local directories until 1793 but seems to have disappeared by the turn of the nineteenth century.

39. LEVETT'S ARMS, Frog Lane (pre-1833–1957)

The Levett's Arms stood on the corner of Frog Lane and Bakers Lane in an area that is now occupied by the Three Spires shopping precinct.

It was first mentioned in 1833 when the landlord was Edward Cork and its address was given as Throgmorton Street. Thomas Cork was the licensee (and gardener) by 1841 and the pub was doing well enough to employ one general servant. Elizabeth Cork, Thomas's widow, had taken over the Levett's Arms by 1871, maintaining the roles of innkeeper and gardener. George Scattergood, landlord in the 1890s, ran a furniture removal business from the pub.

In 1931 the occupants of the Levett's Arms had a narrow escape when a fire broke out in the early hours of 2 March. The landlord, Cyril Swann, sent by his wife in the middle of the night to investigate strange noises, discovered a fire in the bar of the pub. The only means of escape for Mr Swann, his wife and their young child was via a bedroom window, the fire having blocked the way to the only door to the outside. The fire brigade arrived promptly and managed to put out the fire, which they believed

had been caused by cigarette ends smoldering away in the sawdust on the floor of the pub. The bar was destroyed but the Swann's were able to carry on business, rather ironically, in the smoke room!

In an otherwise uneventful history the pub carried on until the 1950s when the whole area was redeveloped and Lichfield's first shopping precinct was built.

Two pubs in this area celebrated national military figures that had made their names in the wars against France in the eighteenth and nineteenth centuries. First mentioned in 1793, the Lord Nelson stood in St John Street opposite St John's Hospital almshouses when the landlord was Thomas Roberts, who later doubled-up as the city's town crier. Later the building became part of Lichfield Grammar School's living quarters and later still it was used by Lichfield District Council.

Like the Nelson, the Lord Rodney was named after a famed naval hero and was situated at No. 70 Wade Street, at the rear of the guildhall. In 1848 it was known as the Admiral Rodney. Owned by the Lichfield Brewery Co. it was another Lichfield pub that was demolished when the shopping precinct was constructed in the late 1950s and early 1960s.

A far more local war leader was also honoured by having a public house named after him:

40. MARQUIS OF ANGLESEY/ANGLESEY ARMS, St John Street and, from 1938, Curborough Road (1817–2013)

The Marquis of Anglesey, situated on the corner of St John Street and the Birmingham Road, just before the railway bridge, was built in 1817 in commemoration of Henry Paget who had been the Duke of Wellington's second-in-command at the battle of Waterloo and afterwards became the first Marquis of Anglesey. Paget's arrival back in Lichfield after the crucial battle was an occasion of great celebration and pageantry in the city.

From 1841 the landlord of the Marquis of Anglesey was William Crompton and he was still running the pub in 1861 when, as an eighty-one year-old, widower he described himself as an innkeeper and builder.

In September 1915, Captain Arthur Robert Katon, who had become the landlord of the Marquis of Anglesey in 1913, was killed while on active service with the South Staffordshire regiment during the First World War. His wife Clara took over the licence and ran the pub until the 1920s.

The pub closed in 1937 and the building became the city's labour exchange before being demolished in the 1950s when the Birmingham Road was widened.

The licence of the Marquis of Anglesey was transferred to a new pub that opened on Curborough Road in April 1938. It was built by J. R. Deacon of Lichfield and was owned by brewers Messrs Ind Coope and Allsopp and was to cater for the new housing estate built in that area of Lichfield. The new pub, popular with locals, was called the Anglesey Arms and its first landlord was Horace Wilson. An advertisement in the *Lichfield Mercury* informed the public that 'The Anglesey Arms now open. Refreshments served under ideal conditions.'

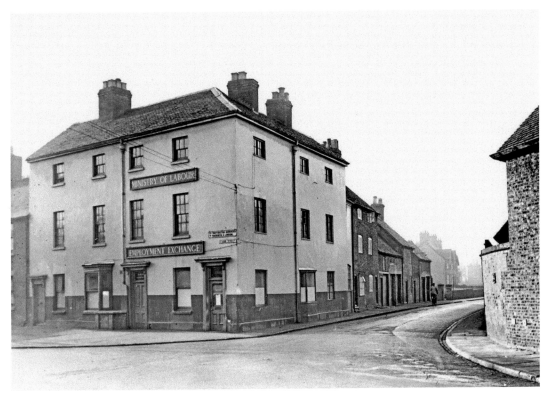

Previously the Marquis of Anglesey, from 1938 Lichfield's Employment Exchange.

This pub too eventually closed its doors in 2013 after being called, for a short time, the White Hart. The pub building was demolished and a Co-operative food store now stands in its place.

41. RAILWAY TAVERN, Levett's Field (pre-1860–c. 1960)
The Railway Tavern stood at No. 11 Levett's Field where the top end of the shopping precinct is now situated.

It dated from 1860 when the licensee was Thomas Smith. In 1911 the landlord was Thomas Hodgkinson who was listed as a licensed victualler and house painter. His wife Alice took over the running of the pub in 1917 when her husband was fighting in the First World War.

However, the Railway Tavern developed somewhat of a poor reputation. The aforementioned Alice Hodgkinson was fined 5 shillings and sixpence for serving alcohol in prohibited hours in April 1917. The landlord in May 1922, Patrick Ryan, was likewise fined for a similar offence. It was also during this landlord's tenure that police were called out to various brawls in the pub and licensing magistrates, on a number of occasions, threatened to refuse to renew the pub's licence. However, the Railway Tavern lasted until the late 1950s when it too was demolished to make way for the new shopping precinct.

42. RED LION, St John Street (pre-1810–1929)

The Red Lion stood at No. 19 St John Street on the corner with Wade Street.

It dated from the early nineteenth century and the earliest recorded landlord was John Askew. In 1861 the landlord was Thomas Moore who was a clockmaker as well as being a licensed victualler. From 1865 to 1884 Thomas Neville ran the pub, and in 1881 was able to employ a servant whose memorable name was Delphena Dempster. When Thomas Neville died the licence passed to his daughter Bessie Nevill, who seems to have altered the spelling of the surname, and who was landlady until 1903 when she retired at the age of sixty-six.

Despite being a well-run and orderly pub, the Red Lion was recommended for closure in March 1929 on the grounds of redundancy, magistrates pointing out that there were three other pubs very close by. The building was later demolished.

43. ROBIN HOOD, St John Street (pre-1767–2000)

The Robin Hood stood at No. 37 St John Street on the corner of Frog Lane.

The first reference to the pub was in 1767 when it was mentioned in *Aris's Birmingham Gazette* of 16 February and when it was known as the Robin Hood and Little John. The landlord at the time was Thomas Tyler and he placed an advert in the paper which read,

> A little man, 5 feet 3 or 4 inches high in a drummer dress and a little girl and two women and two children, more than one of the women was supposed to be his wife... left without paying leaving a horse behind.

The advert placed by the landlord went on to say that if the group did not return to pay he would sell the horse, saddle and bridle 'to defray all charges'.

In June 1884 a serious disturbance took place in the centre of Lichfield when a large number of men belonging to the Staffordshire Yeomanry drunkenly stormed the stage of the Garrick Theatre during a performance of Gilbert and Sullivan's *Princess Ida*. Apparently they were keen to visit the actresses' dressing rooms and when they were stopped from doing so the fighting spilled out into the street, with local men joining in the fracas. When news of the brawling was sent to the Yeomanry's Commanding officer, Colonel William Bromley-Davenport, he quickly headed to the city centre to attempt to quell the trouble. Unfortunately as he was walking past the Robin Hood the sixty-three-year-old colonel suffered a heart attack and died. As news of the tragedy filtered out the fighting subsided but not before the statue of Johnson in the Market Place had been daubed with black paint. (Incidentally, Hugh Bromley-Davenport, the son of the unfortunate colonel, would eventually play cricket for England.)

Things seem to have improved somewhat by 1908 when the landlady, Mrs Emily Ffrench, was able to boast that the Robin Hood Inn had 'Lichfield ales, wines and spirits of the finest quality [a] motor garage, good accommodation for cyclists [and] good stabling.' Between 1913 and 1917 the landlord was Ephraim Badrick (unfortunately not as John Shaw suggests Ephraim Baldrick!).

Rebuilt in the 1930s, the Robin Hood was to have rather a sad demise, suffering a number of name changes in its latter years including the City Gate, the City Frog and the highly inappropriate Funky Frog! Perhaps it was something of a mercy when the pub closed its doors for the final time and the building was subsequently demolished in 2000.

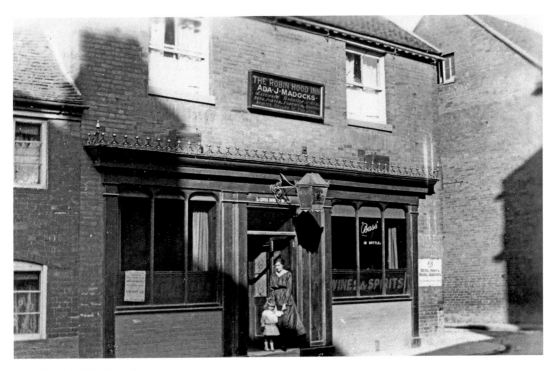

The Robin Hood *c.* 1917.

Chapter Four

Beacon Street, Sandford Street and Queen Street

Like Greenhill the Sandford Street area was, in the nineteenth century, sometimes prone to antisocial and violent behaviour, generally blamed on the large number of public houses to be found there at the time. Beacon Street was a better-behaved area with its pubs just a little way out of the city centre. Few pubs now remain in this part of Lichfield but those that do are as follows:

44. THE FEATHERS, Beacon Street (pre-1851–present)

The Feathers stands in Beacon Street a ten-minute or so walk out of the city centre. First listed in 1851, when its landlord was Richard Taylor, it was, for a time, known as the Prince of Wales Feathers.

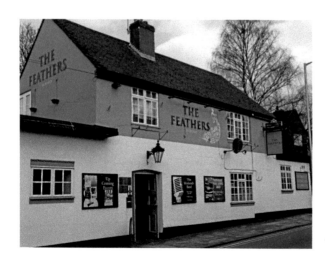

The Feathers.

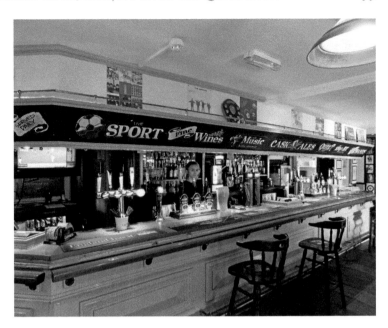

The long bar of
The Feathers.

Perhaps because of its slightly out of the way position, the above landlord, Mr Taylor, was fined 6 shillings plus costs in December 1865 for opening his pub during prohibited hours. A similar charge was made against John Sharrott, the landlord in 1886, who was fined 10 shillings for the misdemeanour. Other than these incidents and another landlord, Samuel Faulkner, who in August 1921 was fined £4 for selling diluted whisky, the pub has had a rather uneventful history.

Today The Feathers is a popular and lively pub and has a reputation for good-value food, regular live music sessions and for showing sporting events on its big-screen television.

45. THE FOUNTAIN, Beacon Street (pre-1818–present)

A short walk away from the Feathers, on the other side of Beacon Street, stands The Fountain.

First listed to Edward Collins in 1818, it was being run by Thomas Gough by 1833. Born in 1804 Gough described himself as a plumber, victualler and assistant overseer although he never specified what, in fact, he was overseeing. Gough was still landlord of the pub in 1871 when it changed its name for a time to the Old Fountain.

The landlord in 1881 was Jeremiah Craddock and in the census of that year he listed his occupations as an innkeeper and a collier. Unfortunately there is no explanation of how he managed to successfully combine both professions.

Unusually for an out of the city centre pub The Fountain hosted a political meeting during the 1880 general election campaign when supporters of the Conservative candidate General Dyott met there. Dyott was elected by a majority of sixteen votes.

The pub, which was owned by the Lichfield City Brewery, was rebuilt in 1916 in a mock-Tudor style. Today the pub is a friendly pub and a popular venue for locals.

Above: The Fountain.

Below: The bar of The Fountain.

46. GEORGE & DRAGON, Beacon Street (pre-1817–present)

The George and Dragon occupied a key position in Beacon Street – next to the toll house where wheeled vehicles often unloaded passengers to avoid paying tolls to enter the city.

Its first listing was in 1817 when the landlord was George Willdey and the street was still known as Bacon Street. At that time the pub was often the venue for auctions such as the one mentioned in an advert in the *Lichfield Mercury* of 14 November 1817 where 'at the dwelling house of Mr George Willdey 2 lots of 2 messuage and gardens' were sold. ('Messuage' is an archaic word for buildings or land being sold.)

The pub has had a peaceful and generally uneventful history – the only controversies surrounding landlords who bent the rules slightly. In 1890, for example, licensee John Sharrott (who had formerly been in trouble for a similar offence at the Feathers) was fined £1 plus 15s costs for selling alcohol during prohibited hours. In 1918 John Henry Smith was fined £15 plus costs for selling fourpenny beer at fivepence a pint and in 1921 licensee Richard Vernon Williams was fined £4 for selling diluted rum.

The large garden of the pub is near to Prince Rupert's Mound, the site where in April 1643 Royalist commander Prince Rupert, Charles I's nephew, had an artillery emplacement during the second siege of Lichfield in the English Civil War. The view from the pub garden over to the cathedral, which was the objective of Rupert's artillery bombardment, is well worth seeing.

Today the George & Dragon, despite reputedly being haunted, remains a cosy, popular and friendly pub, a short walk out of the city centre.

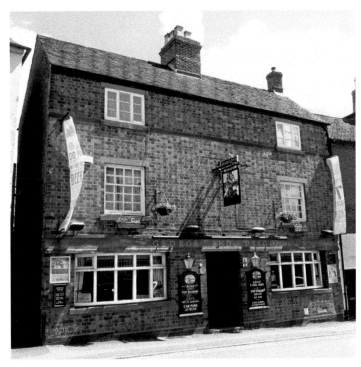

The George & Dragon.

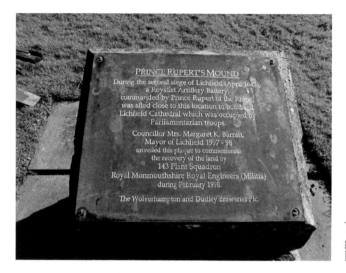

The George & Dragon's garden, part of Lichfield's history.

The view towards Lichfield Cathedral.

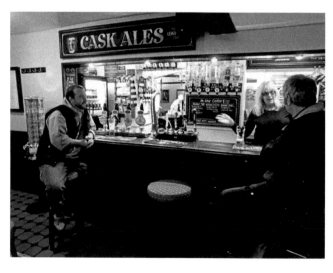

The bar of the George & Dragon.

47. HORSE & JOCKEY, Sandford Street (pre-1781–present)

The Horse and Jockey has stood at No. 8 Sandford Street since at least 1781 when it was marked on a map of the city drawn up by John Snape in that year. Its name provides another connection to the Lichfield races, which were popular from 1702 until they came to an end in 1895.

The pub's first recorded landlord was Thomas Meacham in 1818; he kept it until 1841. Daniel Smith, a Burton man, took over the Horse & Jockey in 1841. Joseph Arrowsmith, who was given temporary authority to be in charge of the pub in 1901, was eventually refused a full transfer of the Horse & Jockey's licence when it was discovered that he had been acting as a bookie and taking bets in Walsall (off-course betting was illegal in Britain until the 1960s).

When one walks down the quiet Sandford Street these days it is hard to comprehend how unruly this part of Lichfield was in the past when it was one of the main routes out of the city. In 1880 landlord John Matthew was summoned by magistrates twice for selling alcohol to a drunken man and was fined on both occasions. In June 1908 Ellen Keenan appeared in court for the forty-second time, charged with improper conduct with a soldier, Private Albert Tipper of the West Riding Regiment, in Sandford Street. She was sentenced to twenty-one days in prison; Tipper was only ordered to pay court costs. In April 1935 a 'violent scene and fracas' took place in the Horse & Jockey when one Henry Bartlette had to be ejected from the pub for being drunk and disorderly and for assaulting the landlord. Bartlette was subsequently fined £1, but was unable to pay and so was sent to prison for fourteen days.

Thankfully these days such events are no more and remain only an aspect of the colourful history of the area. The Horse & Jockey survives to this day as a very popular meeting place and watering hole and seemingly goes from strength to strength, having survived a hiatus a few years ago when it briefly and unaccountably changed its name to the Los Angeles Rock Café.

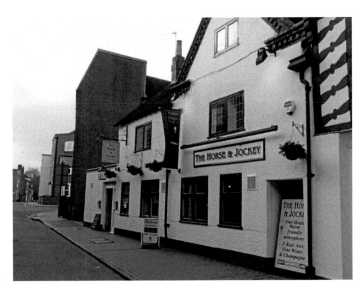

The Horse & Jockey,
Sandford Street.
Inside the Horse &

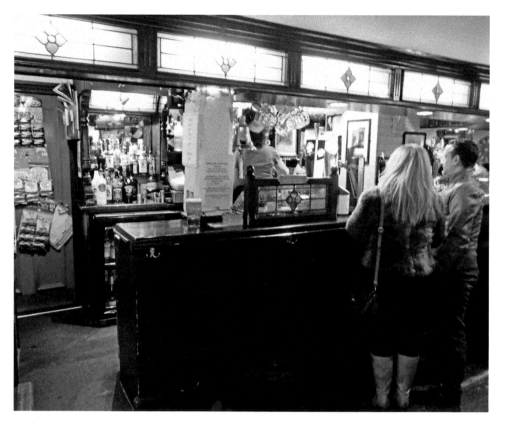

Jockey.

48. QUEEN'S HEAD, Queen Street (1835–present)

Built in 1835, when the construction of Queen Street was completed, the Queen's Head name was actually transferred from a pub in Bore Street (which was renamed the Turf Tavern and later the Prince of Wales). The first listed landlord was Thomas Wright who described himself as a victualler and a bricklayer.

A landlord of the pub who seems to have made a profound impression on the people he knew was Philpot Palmer, who was licensee of the Queens Head from the 1860s until 1885. In 1938 local historian J. W. Jackson remembered him in glowing terms, writing, 'He was well read and broad-minded. His tall erect and stalwart figure gave him an imposing appearance. His smoking room was the meeting place of a number of prominent businessmen and the topics discussed were generally of an interesting and educative character. He was temperate himself and never encouraged excess in drinking but rather discouraged it.'

In the nineteenth and early twentieth centuries inquests at the pub were common occurrences. In February 1885, for example, the inquest into the death of Thomas Henney took place. He had been landlord of another Lichfield pub, the Holly Bush, and had been killed when he fell from his pony and trap, breaking his spine. Another inquest

Above: The Queen's Head.

Below: The interior of the Queen's Head.

took place in March 1900 when local councillor George Green was found with a shotgun next to his body and a severe wound to his head. The jury was undecided about the cause but felt that suicide was the probable reason for the man's death.

The Queen's Head today remains a very popular and atmospheric city pub just a short stroll out of the city centre.

Among the many pubs that have disappeared over the years are:

49. ANCHOR, Beacon Street (pre-1833–1891)

The Anchor stood a good way out of town on the corner of Abnalls Lane and Beacon Street.

It was first listed as a beerhouse in 1833 when its landlord was Thomas Baker. Long-time landlord George Godwin – 1860 to 1890 – kept himself busy as a master tailor as well as being a publican and also ran a small sweetshop at one end of the pub.

However, the man that took over the pub in 1890 was to cause a scandal that would see the closure of the pub just one year later and lead to the building's eventual demolition. William Henry Cheeseman was brought to court in February 1891 charged with 'keeping his pub as a brothel' after soldiers had been found in bed there with 'women of ill-repute' and also, in one instance, with a twelve-year-old boy. Cheeseman offered no defence and was sentenced to a fine of £20 with costs, or three months in prison. He told the court that he could not pay and so was gaoled. As a result of this incident magistrates refused to renew the licence of the Anchor and in December 1891 the pub building was sold for £165 at an auction at the George Hotel. Some years later the building was demolished and the land sold.

Today the site forms part of the gardens of private houses.

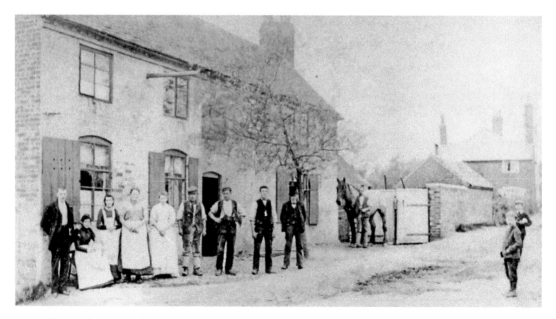

The Anchor, once in Beacon Street now no more.

50. COACH & HORSES, Beacon Street (pre-1740s–c. 1840s)

The Coach and Horses at No. 13 Beacon Street was one of Lichfield's famed coaching inns.

According to Chris Upton in his book *A History of Lichfield*, Anthony Jackson, the landlord in the 1740s, ran a stagecoach service to London every Monday morning that arrived in the capital on Wednesday evening. The cost was a considerable 37s (£1.85) and the baggage allowance was 14 pounds.

An old Lichfield legend suggests that the Coach & Horses was one of the haunts of the famous highwayman Dick Turpin when he journeyed between London and York. The story has it that for a time in the 1730s he was in love with the landlady of the inn whose name has come down in history simply as Nance. The legend also stated that when he was in the area Turpin would practise his highwayman's craft on nearby Cannock Chase between Gentleshaw and Milford where travellers by horse, wagon or coach used a well-worn track and where the danger of footpads and highwaymen was always high.

Highwaymen tended to ply their trade in other parts of the countryside around Lichfield too. In January 1761, for example, an unspecified newspaper report quoted

The Coach & Horses, once a famous coaching inn.

in Brian Haughton's book *Coaching Days in the Midlands* related how: 'Several inhabitants of Lichfield were stopped on Whittington Heath on their return from Tamworth market by a single highwayman on a bay horse with a bald face. From one, Mr Gregory, a dyer, he took 9d and a silver coat button, from Mr Henry 9 or 10 shillings and from a poor pie woman, half a crown. Broughton, an old man who sells linen cloth, escaped by galloping, although his horse was loaded. The rogue fired a pistol but happily missed him.'

In October 1771, along with a number of other Lichfield inns, the Coach & Horses was mentioned on a bill for the election campaign expenses of joint candidates George Anson and Thomas Gilbert (these being the days when the small city of Lichfield returned two members of Parliament). At the time it was common practice for election hopefuls to 'bribe' voters by plying them with drinks on election day. Potential voters at the Coach & Horses were 'canvassed' to the tune of £8 8s and 8d (£8.47).

The Coach & Horses did not survive the demise of the coaching era, a trend that, for a time, brought an economic decline in the fortunes of Lichfield where so many jobs and occupations were connected to stagecoaches, horses and their related equipment. The inn closed in the 1840s and became a private residence called Whitehall, a name by which the building is still known. For a short time in the 1920s the Whitehall was a private hotel and the proprietor, E. J. Bennett, branded the hotel as the 'Famous Coaching Inn of Olden Days.'

51. HEN & CHICKENS, Sandford Street (1841–1936)

The Hen & Chickens, which stood at No. 161 Sandford Street, was first documented in 1841 when James Nicholls was the licensee.

Like so many other public houses at the time the Hen and Chickens was used as the venue of inquests into sudden and unexplained deaths of individuals in houses nearby. One particularly tragic example of this took place in April 1887 when the city coroner examined the circumstances surrounding the death of seven-year-old William Lewis who was found dead at his home in Sandford Street. After examining the evidence the coroner's verdict was that the boy had died as a result of 'having received no medical assistance and in a natural way, by a visitation of God'. In the days before the National Health Service, obtaining medical treatment was usually a matter of whether a person could actually afford to pay for a doctor's visit.

The Hen & Chickens suffered from the general nature of poor behaviour in the Sandford Street area at the time. For example, in December 1901, a notorious character, William Caveney, who lived in Lower Sandford Street, was found guilty of being drunk and disorderly and damaging two pint jugs and three panes of glass at the pub. He was told to pay a fine or spend three weeks in prison. Caveney replied: 'I shall have my Christmas dinner in there!' George Davis, husband of the landlady, Rebecca Davis, did not improve matters much in February 1908 when he was found guilty of being drunk on the premises and fined 5s, and Sarah Mynard of Sandford Street was fined for refusing to leave the pub when requested to do so in May 1908 and for subsequently breaking one of its windows.

In 1936 the Licensing Magistrates, on account of the dilapidated state of the building, referred the Hen & Chickens for compensation. This dilapidation included a large hole in the roof that had, apparently, been caused by a 'thunderbolt' hitting the pub in the previous year. Nothing had been done to repair this hole or to improve the general look of the pub inside or out. In 1937 the owners of the Hen & Chickens, Messrs Ind Coope and Allsopp, were paid compensation of £700 and the building was demolished sometime later.

52. LEMON TREE, Beacon Street (pre-1833–1915)
The Lemon Tree stood at No. 125 Beacon Street and was first mentioned in 1833 when the landlady was Sarah Whittaker, another of the doubtless formidable women that ran Lichfield public houses. In the 1890s Frederick and Annie Beer ran the pub, appropriately enough.

The Lemon Tree closed in 1915 when tougher licensing regulations restricting the number of licences in any particular area were brought in. Today the building is a private residence still called The Lemon Tree.

The ex-Lemon Tree public house.

Another private home, once the Little George pub.

53. LITTLE GEORGE, Beacon Street (1860–1956)

The earliest listing for the Little George was in 1860 when the landlord was Henry Charles who ran it until 1880. The building stood on the corner of Beacon Street and Anson Avenue and is today a private house. It closed in 1956 when its licence was transferred to a new pub, the Windmill in Wheel Lane.

54. PHEASANT, Beacon Street (1861–1909)

The Pheasant is first mentioned in 1861 when the licensee was Joseph Gamble; his widow Ann Gamble then ran it for a number of years. The Pheasant stood in Beacon Street until 1909 when it closed as a pub. It later became the Pheasant Café. The building today is still there and can be recognised by its prominent archway.

The ex-Pheasant public house.

55. ROYAL OAK, Sandford Street (pre-1781–c. 1930s)

The Royal Oak in Sandford Street was shown on John Snape's map of 1781.

Besides hosting the usual number of inquests the pub had a rather uneventful history, although an amusing incident took place in November 1899. George Sedgwick, a net maker of no fixed abode, went into the Royal Oak pretending to be deaf and dumb. The landlord, Walter Ellett, doubtless feeling sorry for the unfortunate man, gave him sixpence. The very next day Sedgwick went into the same pub and asked the landlord for half a pint of beer. Sedgwick was found guilty of obtaining money by false pretences and was sentenced to one month in gaol.

In 1926 the Licensing Magistrates, intent on reducing the number of pubs in the city, decided not to renew the Royal Oak's licence and the pub's owners, the Lichfield Brewery Co. were forced to close it. The building was later demolished when the area was redeveloped.

56. TANKARD, Sandford Street (pre-1771–c. 1910)

The Tankard was another of the many pubs in Sandford Street that have now disappeared.

First mentioned in a bill for voters' election drinks in October 1771 (voters were treated to £6 14s worth), the pub was handily placed at the lower end of the street, for serving travellers going to and fro on the old route to the towns of the Black Country.

For many years the licensee of the pub was Joseph Slater who was still running the pub in 1861 in his nineties. His wife, Sarah, who succeeded her husband as the licensee, was forty years his junior.

57. TURK'S HEAD, Sandford Street (pre-1781–1990)

The Turk's Head (a name harking back to the crusades) was one of the Lichfield inns that served the important coaching route between London and Liverpool in the eighteenth and first half of the nineteenth centuries.

In the 1850s the landlord was Joseph Stevens who, as well as being an innkeeper, had a second job as a master tailor.

In Victorian times the poor reputation of Sandford Street kept the police busy maintaining order in the area. For example, in April 1865, William Wright was fined £1 plus costs when he was found guilty of assaulting the landlord William Reeves, who had asked the drunken offender to leave the premises. In May 1884 John Mullarney was sentenced to fourteen days in gaol with hard labour after he was found to be drunk standing outside the Turk's Head and threatening to fight passers-by. In 1902 and 1903 both the landlord and his wife were fined for being drunk on their own premises.

The Turk's head was another of the many pubs in the city where inquests on deceased persons took place. For example in February 1912 an inquest into the death of seventeen-year-old Herbert Hall was held. He had died suddenly at his home in nearby Flowers Row and the coroner's verdict was that the unfortunate youth had been stricken with acute peritonitis.

The Turk's Head became a popular venue in the 1970s for various musical events held at the weekend. For example, an advert for one such event appeared in the *Lichfield*

Mercury in February 1976: 'Weekend entertainment, Friday and Saturday – Piano and Drums (free and easy) Sunday – Country Sounds (country and western duo).'

Despite its popularity the Turk's Head finally closed its doors in 1990 and the building was demolished prior to the completion of the Swan link road in April 1991.

58. WHEEL, Beacon Street (1810–1893)

The Wheel stood on the corner of Beacon Street and in the 1860s was known as the Catherine Wheel. Following a number of incidents dealt with by the police the authorities refused a renewal of the licence in 1893 and the pub closed. The nearby brewery of A. W. and W. A. Smith was bought out by the Lichfield Brewery Co., which sold off the brewery buildings, along with the Wheel, to the nearby Tuke and Bell foundry.

Chapter Five

Bird Street

On Bird Street can be found the real jewels in the crown of Lichfield's historic pubs. Today the street is a hub of eating and drinking establishments that has something for everyone and any visitor to Lichfield will have a hard job to choose between the varied venues available. One of the many restaurants and bars in Bird Street is the Gatehouse, a J. D. Wetherspoon's pub on the corner with the Friary and which is housed in an imposing building that used to be the National Provincial Bank. Bird Street is often a lively meeting place, especially at the weekend, but, as we shall see, in the past Bird Street was often lively in a number of different ways:

59. GEORGE HOTEL (pre-1650–present)

The George Hotel has more history attached to it than most other such establishments in the city.

Coaches were regularly operating from the George by the 1650s when the George was already being described as 'a very old hostelry.' It soon became one of the foremost coaching inns outside the capital city and with its extensive stables to its rear it must have been a constant hive of activity during the heyday of the stagecoach. Every day coaches left the George for London, Manchester, Birmingham, Chester and Holyhead. Towards the end of the coaching era improvements in roads meant that travel to London had become quicker. For example by 1832 a coach called the Rocket left the George every day (except Monday) and arrived at the Golden Cross Inn in Charing Cross just fifteen hours later, having visited Atherstone, Hinckley and Northampton. Looking after the roads into and out of Lichfield was the local Turnpike Trust who held regular meetings at the George from 1789 onwards. Generally speaking they did a good job as the roads around the city were among the best in the Midlands.

The coaching industry was not without its pitfalls, however. In 1817 the then landlord, Mr Webb, lost two of his best horses when they were killed by flying stones kicked up by the hooves of the two lead horses in a team pulling a coach. Broken wheels and highwaymen were other problems regularly experienced by coach proprietors and passengers.

In 1704 the noted playwright George Farquhar stayed at the George while writing his play *The Recruiting Officer*. The famous Lichfield-born eighteenth-century actor

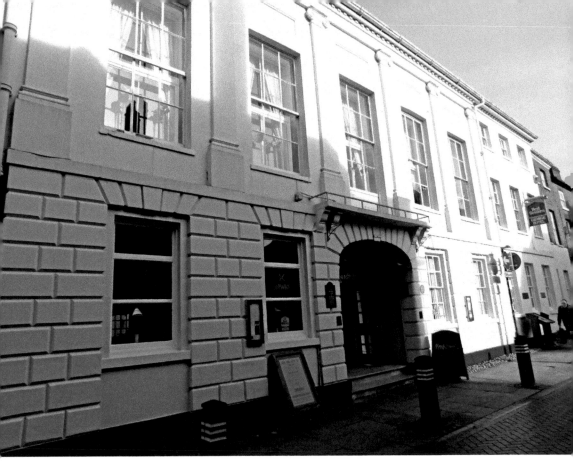

Above: The George Hotel.

Below: Bird Street and the George Hotel, early twentieth century.

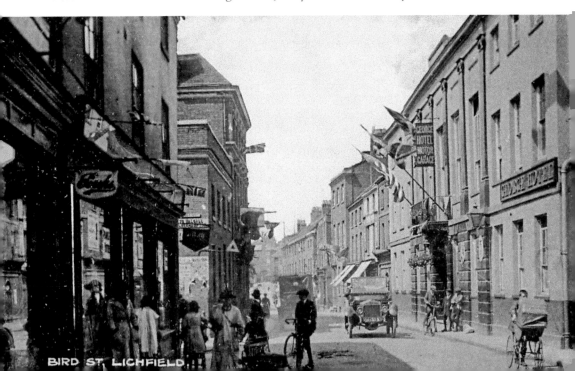

David Garrick acted in the play, at the age of eleven, when it was performed at the city's Bishop's Palace. Another of Farquhar's plays, *The Beaux' Stratagem*, is set in Lichfield with one of the characters, Boniface, the landlord of the George. Other characters include Lady Bountiful and Gibbet, a highwayman.

According to local historian Howard Clayton it was the George that sponsored Lichfield's first documented cricket match in July 1830. The game was played between Lichfield and Tamworth and was held on nearby Levett's Field, which was owned by the George. Lichfield won the match by fifteen runs and at 6.30 p.m. the two teams sat down to 'a sumptuous dinner' at the George.

In May 1854 the funeral of Henry Paget, the first Marquis of Anglesey, took place. The people of Lichfield considered the marquis, who had been second-in-command at the Battle of Waterloo, a hero. His coffin arrived at the city's Trent Valley railway station and was then transported to the George by a hearse pulled by six horses down streets with closed shops and crowded with silent locals. At the George the coffin was taken upstairs to the assembly room where it was placed on a catafalque flanked by four silver candlesticks. Paget's body lay in state for the rest of the day and was visited by hundreds of Lichfield folk. The next day the coffin processed to the cathedral accompanied by a military band playing the Dead March and the coffin was interred in the Paget family vault.

In times past elections in the city were keenly fought and often got out of hand. In 1826, for example, the George, being the headquarters of the city's Whig party, was attacked by a mob supporting the rival Tories. Windows were broken and the local militia had to be sent for to restore order. Things became just as heated during the campaign for parliamentary reform in the 1830s. Following the General Election of 1831 the two victorious Lichfield members of parliament, Sir George Anson and Sir Edward Scott, both Whigs, celebrated at the George with toasts to 'Lord John Russell and Reform.' Even after the Reform Act of 1832 Lichfield was still allowed to have two MPs and not until 1868 was the number reduced to one. Even as late as 1895 election time still sparked the occasional bout of violent behaviour in the city. In July of that year forty men from Walsall sporting 'Tory colours' threw rotten fruit and manure at their political rivals in Bird Street on General Election day and were subsequently charged with disturbing the peace.

Entertainment of various sorts was always an important feature of life at the George, balls and dinners being regular events in the hotel's grand assembly room. For example, in January 1818 'a ball and supper' was held in honour of King George III's queen. The *Lichfield Mercury* vividly described how the ballroom was 'brilliantly lighted and ornamented' and how the guests included 'the cream of local society' including the Ansons, Sneyds, Levetts and Swinfens, as well as members of the military stationed in the city. The ball started at 9 p.m.; dancing commenced at 10 o'clock and carried on until 1 a.m. when the thirty couples present sat down to 'an elegant supper' during which they were entertained by the cathedral choir and the band of the Enniskillen Dragoons. Dancing started again 'with increased animation' at 2 o'clock and continued until 5 a.m. 'when the company separated'.

From 1856 the County Ball was sometimes held at the George (it also took place at the guildhall or St James' Hall in Bore Street). This was one of the city's chief social events of the year. The *Lichfield Mercury* described the scene in 1911 when, from 9.15 p.m., a 'constant stream of cars' dropped guests off in Bird Street. When the ball was in full swing some 300 guests were present and to accommodate them a large marquee with a specially laid parquet floor was set up in the spacious rear yard of the George and there dancing took place.

Other organisations such as the local Freemasons also held their celebratory dinners and dances at the George, for example in December 1865 when 'brethren' were requested to attend in their 'masonic clothing and jewels'. In 1735 a gentlemen's drinking club known as the 'Court of Truth' met weekly at the George and in February 1887, rather ironically perhaps, a meeting of the Women's Temperance Union took place there.

In March 1833 the famous magician Ching Lau Lauro performed at the George. The *Lichfield Mercury* described Ching as an 'extraordinary and unrivalled performer' who was able to astonish the 'nobility and gentry' of the city by exhibiting his 'gymnastic, conjuration and ventriloquial skills'. His act included imitating the singing of birds, juggling and 'deception and enchantments'. Little is known about Ching Lau Lauro, who was very popular and famous in Britain in the 1820s and 1830s. He was not Chinese, but was probably born in Cornwall in around 1806 and almost certainly started as a travelling circus performer. He was responsible for beginning the tradition of magicians appearing in mysterious Chinese costume and was the first one to create the illusion that he was able to float in the air while juggling and also created spectacular effects with the use of limelight. Ching Lau Lauro was not the only unusual entertainment to be provided by the George. In 1818 an exhibition of automata was held there and in May 1880 the George presented performances by Dr Gough, 'the noted conjuror'. Gough amazed his audience with escapology feats and also presented 'a dark séance' where he demonstrated how bogus spiritualists used tricks to convince people they were in touch with the spirit world.

In April 1910 the George had a part to play in the city's first encounter with an aeroplane. Taking part in the Manchester to London air race, pilot Claude Grahame-White was forced to land his faulty plane in a nearby farmer's field and while waiting for his plane to be fixed dined at the George. Meanwhile the farmer in whose field he had landed was busy charging people to see the plane. As it turned out the flimsy aeroplane was further damaged by a gust of wind and Grahame-White had to abandon his journey and arrange for his aircraft to be taken to London by train.

By the twentieth century the George was describing itself as a 'Family, Commercial and Posting House' and continued to be a hub of the local community and a meeting place of the great and good. Other organisations that regularly held their celebratory dinners at the George were the local Lawn Tennis Club, the Lichfield branch of the National Farmers' Union and the annual dinner of the Johnson Society. At the latter guests were served with the good doctor's favourite food including (for Johnson had a prodigious appetite) beefsteak puddings, oysters, mutton and apple pie with cream and toasted cheese. The meal was always washed down with lots of ale and finished off with punch and the smoking of long churchwarden pipes.

Today the George Hotel is owned by the Best Western group and remains one of the great fixtures of Lichfield life, attracting guests from far and wide. The hotel's lounge bar, always a good place to find real ale and other fine drinks, is friendly, cosy and a good place to relax after a busy day.

The cosy and comfortable lounge bar of the George Hotel.

Comfort and a spot of luxury in the George Hotel.

The ornate fireplace, the George Hotel's lounge bar.

60. KING'S HEAD (pre-1408–present)

The King's Head in Bird Street is one of the oldest public houses in Lichfield. First mentioned at the beginning of the fifteenth century, when it was called The Antelope, it had become known as the King's Head by 1650, although it is unclear which king its name actually refers to.

By the eighteenth century it had become one of the most important coaching inns in the city, with coaches such as *The Herald*, which served the important route between London and Manchester and *The True Blue*, which travelled to Birmingham, arriving or leaving each day. An advert for a new coach, *The Saint Patrick*, in 1831, gives a flavour of what such journeys were like at the time:

> It leaves for London each evening except Sunday at 6 o'clock and arrives in London the following morning punctually at half-past nine. The above coach leaves the same office every morning at 8 o'clock for Liverpool where it arrives the same evening at ten minutes before six. Performed by the obedient servants Waterhouse, Bretherton, Wakefield and Waddell. Observe all parcels sent to London by this coach arrive in time for the morning delivery.

On 25 March 1705 Colonel Luke Lillingston raised a new regiment of volunteers at the King's Head, an event that a plaque on the outside wall of the pub commemorates. The regiment became the 38th Regiment of Foot, and eventually the South Staffordshire Regiment, and would go on to perform distinguished service in the American War of Independence, the Napoleonic War, the Crimean War and the two World Wars of the twentieth century. The regiment amalgamated with the North Staffordshires in 1959 to form the Staffordshire Regiment but the name was lost entirely in 2007 when the Staffords were incorporated into the Mercian Regiment. However, the name is proudly kept alive in the pub to this day by memorabilia and artifacts relating to the regiment's history on the walls of the pub. A regimental museum at Whittington Barracks (a short drive out of the city) further commemorates the regiment's story and is a collection well worth seeing.

The King's Head very nearly disappeared in the 1930s when two serious fires damaged parts of the historic building. The first occurred in June 1932 when the long-time landlady, Mrs Shellcross, had to escape from a first-floor window and, as a result, fell 15 feet to the pavement below. Luckily the Lichfield fire brigade turned up promptly and managed to put out the fire before it took hold, but walls were 'scorched and blackened' and the whole building soaked with water. The second fire took place in December 1933 when a great deal of damage was caused when an old wooden beam near the dining room chimney burst into flames. Again, luckily, no one was seriously injured in the blaze with the then landlord, Major Evans, leading his family and the hotel guests to safety. The fire brigade again managed to save the building but the dining room and the upstairs assembly room were extensively damaged.

In city pubs that have so much history attached to them it is little wonder that ghost stories abound, and the King's Head is no exception. It is said that the pub is haunted by no less than three separate spectres. The first such ghost is referred to as

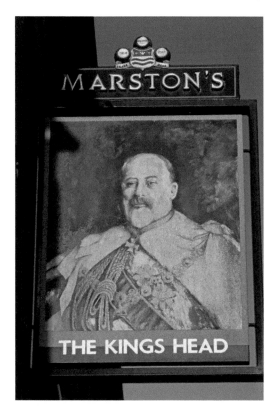

Right: The sign has changed over the years; currently it represents Edward VII.

Below: The plaque on the outside of the King's Head.

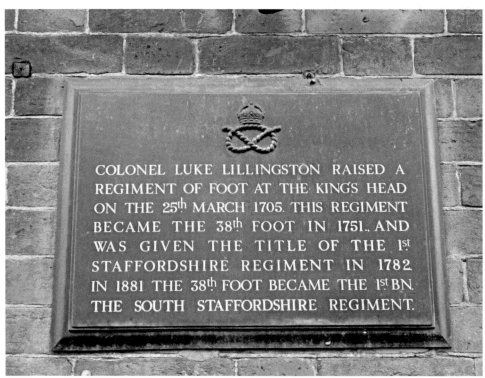

COLONEL LUKE LILLINGSTON RAISED A REGIMENT OF FOOT AT THE KING'S HEAD ON THE 25th MARCH 1705. THIS REGIMENT BECAME THE 38th FOOT IN 1751. AND WAS GIVEN THE TITLE OF THE 1st STAFFORDSHIRE REGIMENT IN 1782. IN 1881 THE 38th FOOT BECAME THE 1st BN. THE SOUTH STAFFORDSHIRE REGIMENT.

the Laughing Cavalier and is supposed to be the restless, but apparently quite jolly, spirit of a Royalist soldier killed during the Civil War in the street outside the pub, with his body subsequently being dumped in the King's Head cellar. In the 1640s Lichfield was the scene of three conflicts between Parliamentary forces and the army of the king, so it is not surprising that various legends and tales of the unquiet spirits of those that met untimely ends tend to grow up around the city. The second ghost of the King's Head is said to be the shade of a former landlord who appears in the cellar in which he died suddenly. Referred to by the name of George by those who have witnessed the apparition, some believers think that the ghost may be that of George Ely who kept the King's Head between the years 1850 and 1870. The pub's third ghost is that of a young girl who supposedly died in yet another fire at the pub in the 1690s. The pub's former landlord, Sid Farmer, who kept the pub in the 1970s and '80s, was convinced that he saw the spectral figure on a number of occasions and others have said that she and her flickering candle can be seen, at certain times, in an upstairs window of the pub.

Throughout the years the King's Head has been an important place for various organisations to gather. Among the many such groups to meet there were the local Licensed Victuallers' Association, which in the 1880s held their annual dinner at the pub, the employees of the London and North Western City and Trent Valley railway stations who also held their annual celebration at the pub in the early years of the twentieth century, and the regular meetings of the local Oddfellows Lodge in the years before the First World War.

One of the strangest gatherings at the pub took place in February 1990 when political parties were campaigning for the crucial Mid-Staffordshire by-election, which took place in March. By-election regular 'Lord' David Sutch, leader of the Official Monster Raving Loony Party, held his campaign launch at the pub. Hundreds crowded into the courtyard of the King's Head and were entertained by Sutch's band. Also present was

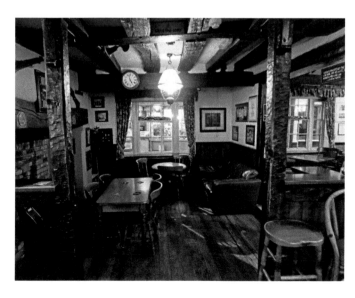

Inside the King's Head.

another 'fringe' candidate Lindi St Clair-Love, a former brothel-keeper who was also known as 'Miss Whiplash!' In the election, which was won by Labour's Sylvia Heal, Sutch garnered 336 votes, a figure that represented 0.6 per cent of the total vote.

In more recent times the pub has remained one of the most popular and atmospheric in the city. With its old beams, fireplaces and military memorabilia it is impossible not to feel a sense of history as one spends time there. The pub has also endeavoured to keep abreast of modern times with regular live music and 'open mic' events being staged.

For visitors to Lichfield it really is one of the attractions of the city that should not be missed.

The George and the King's Head remain to this day but other Bird Street pubs have unfortunately disappeared:

61. ROSE & CROWN (pre-1781–1904)
The Rose & Crown stood in Bird Street next to the alleyway that led to Friars Walk and then to the Bowling Green.

Previously known as the Bear's Head, it was first mentioned on Snape's map of 1781 and became the Rose & Crown in around 1833 when William Wheatley was the landlord. The pub, owned by the Lichfield Brewery Co., closed in 1904 one of the victims of the drive to reduce the number of public houses in the city.

62. SWAN HOTEL (pre-1535–1989)
The Swan, for so long one of Lichfield's prized old coaching Inns, stood proudly in Bird Street.

According to Chris Upton it was first mentioned in 1392. By 1535 it was known as the Lily White Swan when it was a galleried inn and was rebuilt as the present-day building sometime during the second half of the eighteenth century.

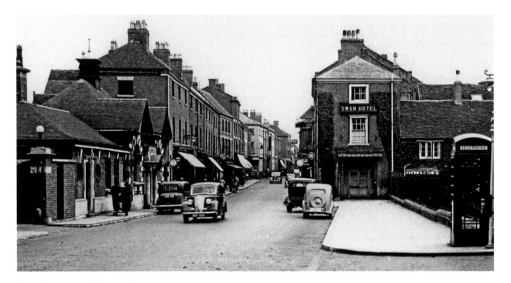

The Swan and Bird Street *c.* 1940s

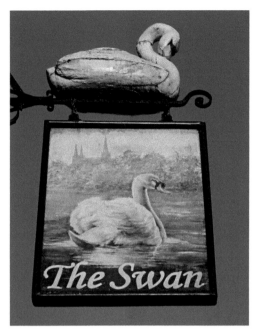

The grand old pub sign.

From 1789 the Swan was one of the venues hosting meetings of the local Turnpike Trust with its illustrious membership that included Erasmus Darwin. At this time the Swan would have been particularly crowded during Lichfield's race weeks, one of the high spots of the city's social calendar. An attraction at the Swan during race week were the daily contests between mains of fighting cocks which would have been, no doubt, very popular with locals and visitors alike. Bailiffs closed down the Swan's cockpit in 1828.

During the eighteenth century in particular the two great inns the Swan and the George became the respective headquarters of the two political parties of the time, the Tories and the Whigs. During election times violent scenes in the street were common and it was usual for the rival HQs to be attacked and suffer smashed windows. It is odd to note perhaps that at a time when so very few actually had the right to vote people seemed to be far more passionate about politics than they are today!

Over the years the Swan has had a number of high-profile visitors. One of these was the Duke of Cumberland in November 1745. On his way to fight Bonnie Prince Charlie's army Cumberland stopped off in Lichfield, camped his army outside the city and dined with his officers at the Swan. The overweight Duke and his entourage got through a great amount of food during their overnight stay including various amounts of beef, bacon, pigs' ears and feet, a calf's head and veal. The meal cost a total of £10 and 13 shillings – a considerable amount at the time.

Another visitor to stay at the Swan was American author Nathanial Hawthorne in 1855. He wrote that the Inn's coffee room was always deserted, noting that the English middle classes, unlike their American counterparts, preferred to stay in their own rooms when they visited hotels.

Mary Anne Evans, better known as George Eliot, famous for writing some of the most renowned novels of the nineteenth century, stayed at the Swan on a number of occasions, notably in March 1856 when she decided to break her train journey from North Wales to Dorset. Another reason why the writer stopped in Lichfield may have been that Eliot's uncle, Samuel Evans, lived in the city. George Eliot based the character of Seth in her novel *Adam Bede* on her uncle.

In the eighteenth and early nineteenth centuries dancing was considered to be one of the marks of refinement and the Swan, along with the George, was the venue of many balls aimed at the well to do of the city. For example an advert for such a one appeared in the *Lichfield Mercury* on 10 November 1815. It was described as a 'Card and Dancing Assembly' and was due to take place on Tuesday 26 November at 8 p.m. Patroness of the ball was a Mrs Proby and Dr Darwin and James Pearson Esq. were named as stewards.

Always an important inn for coaches to stop at, change horses and enable passengers to have a comfort break, a meal or an overnight stay, by 1833 coaches left the Swan regularly for London and Liverpool. By 1842, with the beginning of the decline of the coaching business, landlord Thomas Dunn rebranded the Swan as a Family Hotel, Commercial Inn and Posting House and no doubt helped to save it from extinction. In order to ensure that business continued the Swan, by 1865, was running a regular omnibus to pick up passengers at the Trent Valley railway station and bring them back to the hotel.

That the Swan was closely linked to the city's establishment can be seen from a meal that the hotel put on in honour of Lichfield's mayor in November 1878. The banquet was attended by the city's great and good including the MP Colonel Dyott. The dinner provided by landlord and landlady Mr and Mrs Trevor consisted of mock-turtle soup, cod, turbot, sole, lobster patties, stewed pigeon, roast beef, mutton, veal, turkey, geese, hares, partridges, pheasants, plum pudding, cabinet pudding, apple tarts, stewed pears and orange jelly!

Less attractive was the flooding that took place in September 1896 after freak thunderstorms hit Lichfield. Flooding was particularly bad in Bird Street where drains could not cope with the deluge. The Swan was badly flooded with the bar, kitchen and several adjoining rooms affected.

Hopefully the extreme weather did not affect the kennel of greyhounds kept by the proprietor of the Swan, Joseph Trevor, from the 1860s to the 1890s. One of his dogs went on to win the prestigious Waterloo Cup. Trevor, who was an Alderman of Lichfield and a well-known and influential figure for many years, died in 1906.

The management of the Swan was always keen to stay in touch with the latest technological developments and by 1915 the Swan Hotel Garage was able to supply the public with 'charabancs, motor brakes, taxis and touring cars for hire' along with 'experienced drivers'.

At the start of the First World War the Swan was the venue for the first meeting of the Lichfield Home Defence Force (the forerunner of the Second World War's Dad's Army). It was open to all men over seventeen and its inception caused worries that some might join it as an alternative to volunteering for the regular armed forces. Two years later, of course, as the death toll on the Western Front mounted, conscription was introduced for all able-bodied men.

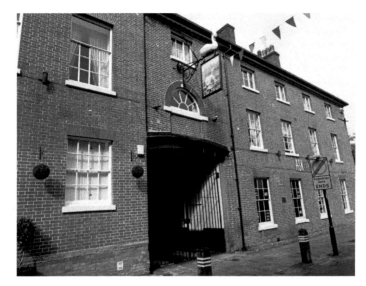

The Swan, once a hotel. now home to two restaurants.

The Swan was such a popular feature of Bird Street for so many years that it was a shock to many in the city when it closed down in the late 1980s. The impressive building remains today and, glad to say, still provides sustenance to locals and visitors alike as it is now divided into two dining establishments: Ask, an Italian restaurant and the Wine House, a bar and restaurant.

63. TALBOT (1760–c. 1860s)

The Talbot stood on the corner of Bore Street and Bird Street. It was originally a private house and was converted into an inn sometime between 1760 and 1772. It was built on land belonging to the Earls of Shrewsbury, whose family name was Talbot, and the first landlord and owner was Humphrey Jackson.

Another of Bird Street's coaching inns, it also specialised in catering for 'gentlemen on horseback'. The Amity stagecoach ran from the Talbot to Leeds and Sheffield daily at 8.45 a.m. every day except Sunday.

Unlike the other coaching inns nearby, the Talbot did not survive the decline in the coaching trade and closed down in the 1860s. The building later became a garage and was eventually demolished in the 1960s to make way for shops.

64. WHEATSHEAF (pre-1771–1912)

The Wheatsheaf was situated in Bird Street next to the Swan Hotel. In 1771 the pub was called the Baker's Arms and was the venue for the last official slave auction in Britain. A horrifyingly matter-of-fact advertisement for the sale appeared in *Aris's Birmingham Gazette* dated 11 November 1771:

> To be sold by auction, on Saturday 30th day of Nov. inst. at the house of Mrs Webb, in the City of Lichfield, and known by the sign of the Baker's Arms, between the hours of three and five in the evening of the said day, and subject to articles that will be

then and there produced, (except sold by private contract before that time) of which notice will be given to the public by John Heeley, of Walsall, auctioneer and salesman, a negroe boy from Affrica, supposed to be about ten or eleven years of age, he is well proportioned, speaks tolerable good English, of a mild disposition, friendly, officious, sound, healthy, fond of labour, and for colour an excellent fine black. For particulars enquire of the said John Heeley.

No one knows what became of the young boy but he would probably have been bought to serve in the home of a local wealthy family, as black house servants were seen, at the time, as a fashionable status symbol.

The Baker's Arms changed its name to the Wheatsheaf sometime between 1771 and 1818 when we know the landlord's name was Thomas Shrigley. By 1909 licensing magistrates stated that they did not think the Swan and the Wheatsheaf should have the privilege of two separate licences because, by this time, both establishments were owned by the same person, Thomas Puzey. Soon after the Wheatsheaf was forced to close as a separate pub and became part of the Swan. Its owner was paid £735 compensation in 1913.

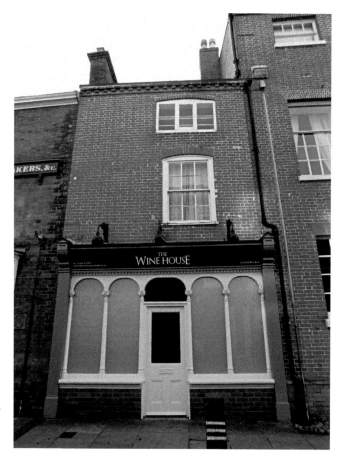

Previously the Wheatsheaf pub, now a bar and restaurant.

Chapter Six

Lombard Street and Stowe Street

Stowe Street, before its pedestrianisation in the late 1960s, was the home of many pubs. It is hard to imagine today what the old Stowe Street would have looked like; only a few old houses, including the medieval Cruck house, now exist as the last vestiges of what once was an important thoroughfare. Indeed before the 1770s Stowe Street was a major road out of Lichfield on the coaching route to the North. In an area that once abounded with pubs, today only one remains – the Doctor Johnson, which is a typical 1960s estate pub a twenty-minute walk from the city centre in Netherstowe Lane. It is a family-friendly establishment providing good value pub food and is very popular with locals. Another pub, the Stowaway, built after pedestrianisation, has long since come and gone.

65. CROSS KEYS, Lombard Street (1833–1970)

The Cross Keys stood in Lombard Street near to what is now the car park of the Jehovah's Witness Hall. The pub was first documented in 1833 when it was being run by James Gee.

During the First World War the Cross Keys was one of a number of city pubs where the landlord, in this case Thomas Ffrench, was required to serve in the Armed forces and where his wife, Emily, took on the licence for the duration. Happily, on this occasion at least, Thomas returned to his pub and was to remain in charge until the 1950s.

The pub closed in 1970 and a newspaper report in May of that year suggested that the building might have been used by Staffordshire County Council as a mental health clinic. However, the building was demolished soon afterwards as part of the area's redevelopment.

66. BRITANNIA INN, Stowe Street (pre-1818–1926)

The Britannia was one of seven pubs that once stood in Stowe Street. It was located on the left-hand side of the Street as one walked out of the city centre towards Stowe Pool, roughly where Stowe Street Shops are now situated.

It was first mentioned in 1818 when the landlord was Thomas Smith. He was succeeded by William Jacocks, who kept the pub until 1865. Licensing Magistrates warned the licensee in 1905, Frank Foster, about having held a flower show at his pub. Although it was not illegal the flower show breached the conditions of the public house's licence.

In 1926 magistrates refused the renewal of the Britannia's licence on the grounds of redundancy, there being ten other pubs within 500 yards, and the pub, which was owned by Messrs Marston, Thompson and Evershed, closed for the final time in December of that year.

67. CHEQUERS INN, Stowe Street (pre-1769–1969)

The Chequers stood at the end of Stowe Street, at No.121, on what is now a traffic roundabout next to Stowe Pool. It was first documented in February 1769 in *Aris's Birmingham Gazette* when the landlord, John Barnes, hosted a meeting of the Friendly Society of Florists and Gardeners at the pub.

In 1891 the licensee was Thomas Wheatley who, as well as being a publican, described himself in the census of that year as a bricklayer. Perhaps because he was holding down two jobs, the landlord could afford to employ a servant at the pub – Martha Jones, aged fifteen.

The dangers of open fires at the time were illustrated during an inquest held at the pub in December 1895 which looked into the tragic death of four-year-old Sarah Elizabeth Cheadle who died after another, even younger child accidentally set fire to her clothes using a lighted piece of paper.

In happier times, and until its eventual demise, the pub was always very popular (particularly with my father-in-law!). When it closed in 1969 the landlady, Edna Lyon, held a farewell party for the pub's regulars. Interviewed by the *Lichfield Mercury* she said: 'It's been very nice here, but we were told it would have to close down when we moved here three and a half years ago.' One thing she would not miss, however, was the pub's resident ghost – 'a hooded figure' she said. 'I've only seen it once but that was enough. I was in bed one night when, suddenly, there he was, just standing there at the

The much-missed Chequers Inn of Stowe Street.

end of the bed. I'd heard a few of the customers speak of the figure but I didn't believe it until then', she added.

Sadly the pub, and presumably its resident ghost, disappeared in December 1969 when Stowe Street was redeveloped and pedestrianised.

68. DOG & PARTRIDGE, Stowe Street (pre 1860–1909)

The Dog & Partridge was a beerhouse that stood at No. 48 Stowe Street on the right as one walked out of the city centre.

It was first mentioned in 1860 when the licensee was Thomas Baker who described himself in the 1861 census as being a beerhouse keeper and labourer. Baker died in 1887 at the age of sixty-eight and his daughter-in-law, Alice, took over the running of the pub for the rest of its existence. In October 1908 Alice Baker was fined 10 shillings for contravening the Food and Drugs Act by selling diluted whisky. The pub closed the following year at a time when magistrates were looking for any excuse to reduce the number of pubs in the city.

69. RING OF BELLS, Stowe Street (pre-1834–1912)

The Ring of Bells was situated at No. 38, a short distance from George Lane and Lombard Street, and stood opposite the city mortuary.

It was first mentioned in 1834 when it was known as the Eight Bells and the licensee was Thomas Walton. Walton, born in 1776, was also the sexton of St Mary's Church next to Lichfield's Market Place. Elizabeth, his wife, was in her seventies when she took over the running of the pub after the death of Thomas. In 1857 William Slater became the landlord and, for the rest of the pub's existence, the Slater family were in charge of it.

In 1911 licensing magistrates, while admitting that the Ring of Bells was well run, was in a good state of repair and that they had never received any complaints from the police about behaviour, refused to renew its licence on the grounds of redundancy, saying that there were many other public houses nearby. In 1912 the pub closed its doors for the last time and its owner, the Lichfield Brewery Co. was paid £1,500 compensation.

70. SEVEN STARS, Stowe Street (pre-1771–1969)

The Seven Stars stood at No. 95 Stowe Street roughly opposite the present-day Partridge Croft.

It was first mentioned in 1771 on a bill which detailed election expenses paid by the candidates in the parliamentary election of that year, where voters at the pub were treated (or bribed) to vote to the tune of £7 and 10s.

In 1911 the pub's tenant at the time, Mrs Kate Busk, was forced to leave after her husband had been found guilty of running a betting concern from the premises. The *Lichfield Mercury*, in March 1911, seemed to have some sympathy with the licensee when it commented that pubs like the Seven Stars did 'a small and precarious business'.

Tragedy struck the Seven Stars in May 1929 when the fifty-one-year-old Mrs Wright, wife of the landlord, who was 'well known and greatly respected', died suddenly. She had been well when her husband took her a cup of tea in the morning but was found

dead in bed later that day by her niece. Mr and Mrs Wright had been licensees of the Seven Stars for nine years and before that had run the Bulls Head for ten years.

The Seven Stars was closed and eventually demolished when Stowe Street was redeveloped at the end of the 1960s.

71. STAFFORDSHIRE KNOT, Stowe Street (1861–1969)

The Staffordshire Knot stood at No. 55 Stowe Street and was first documented in 1861 when it was listed as a beerhouse. The landlord at that time was sixty-three-year-old Thomas Foster who described himself as a beerhouse keeper and a Chelsea Pensioner. By 1891 the pub was run by William Mansell who also ran a coal dealing business from the pub.

Like many other public houses in the city the Staffordshire Knot was often used as a venue for inquests into the sudden deaths of local people. One such tragic example took place in November 1911 when the death of Henry Mears was looked into. Sixteen-year-old Henry, who had lived with his aunt in Stowe Street, had been found dead in the canal under the Shortbutts Lane bridge. The inquest decided on a verdict of suicide.

In the 1960s the Staffordshire Knot went the way of all the other Stowe Street pubs and was closed and demolished.

Chapter Seven

Out of the City Centre

The following pubs are not marked on the map and are outside the city on routes leading out of Lichfield. In the past some were important stopping-off places for travellers coming into or leaving the city. Many have now closed but those that still exist often provide excellent food and drink to those residents and visitors who seek them out. They include:

72. DUKE OF WELLINGTON, Birmingham Road (pre-1818–present)

The Welly, as it is known by locals, is today a friendly and popular pub that is well worth the fifteen-minute walk it takes to reach it from the city centre.

Originally a canal-side pub, it was named after the famous Duke who in 1815 defeated the Emperor Napoleon at the Battle of Waterloo. The Summerfield family, who were also coal dealers, ran the pub for fifty years in the nineteenth century. The landlord in 1881 was Joseph Genders who described himself, in the census of that year, as an innkeeper and a farmer of 20 acres, employing two men. The 1911 licensee, Arthur Barnes was a house decorator as well as a publican.

Like other Lichfield pubs it was for many years, prior to the First World War, used for inquests of those who had met with untimely ends, often in the nearby canal. For example, in June 1865 the pub was the venue of an inquest into the death of a young boy named William Wiggin who had been found dead in the canal that was, in those days, just behind the pub. The boy was the stepson of lock keeper Samuel Cartmale. A verdict of accidental death was reached. In July 1892 an inquest looked into the death of fifty-two-year-old John Leabond, a wheelwright. His son testified that recently his father had been 'queer in his mind' and had twice been in the local 'lunatic asylum'. A verdict of 'suicide whilst in an unsound mind' was reached on the unfortunate man. Even more tragically, in June 1898, an inquest was held into the death of Lilly Elizabeth Hearn, a seven-year-old whose body had been found in the canal six days before. She had been sent to the Duke of Wellington by her parents to fetch a jug of beer and apparently tripped on an iron mooring ring and had fallen into the water; the coroner returned a verdict of accidental drowning. However, in the days when suicide and attempted suicide was a crime, Samuel Boston was fined 1s plus costs in the police court after threatening to kill himself by jumping off the same bridge.

Above: The Duke of Wellington.

Below: Inside the Duke of Wellington.

Today the canal has gone but the bridge (altered in 1935 to make it less of an obstacle to motor traffic) can clearly be seen just before the pub and its car park.

Another canal-side pub that was at one time to be found in the city was the White Lion, which stood on the London Road at St John's Wharf and dated from before 1818. For many years David Wood, who was also a coal merchant, ran the pub. With the coming of the railways canal traffic died and with it also went the White Lion.

73. HORSE & JOCKEY, Tamworth Road (pre-1881–present)

The Horse & Jockey stands on the Tamworth Road at Freeford close to Lichfield Rugby Club and until the 1950s was part of the Freeford estate once owned by the Dyott family.

Originally the Horse & Jockey was a beerhouse supplying those travelling to and from Tamworth. Its name is another reminder of the once very popular and important Lichfield race meetings that used to take place in nearby Whittington until army barracks were built there at the end of the nineteenth century.

In 1881 the landlord of the Horse & Jockey was Thomas Hurd who was described in the census of that year as a beerhouse keeper and a gardener. The pub was still a beerhouse in 1933 when the then landlord, Alfred Smith, applied for a licence to

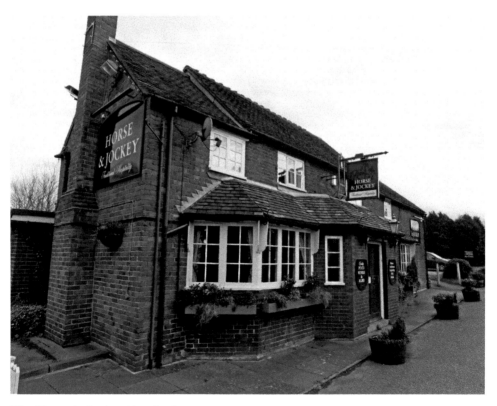

The Horse & Jockey, Freeford

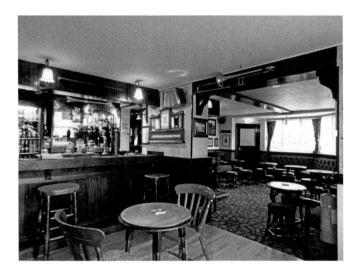

Inside the Horse
& Jockey.

sell wines and spirits, an application that inexplicably was refused by magistrates. However, the Horse & Jockey did become a fully fledged pub at a later date.

The Horse & Jockey today is very popular and has become rightfully renowned for its excellent beer and food.

74. SAXON PENNY, Stonneyland Drive (2013–present)

The Saxon Penny opened in 2013 and was a much-needed pub built on the new Walsall Road estate next to the Waitrose store. It was named in honour of the Lichfield Hoard, the largest ever discovery of Anglo-Saxon gold and silver which was found in a field at Hammerwich in 2009, a couple of miles from where the pub now stands. The pub, part of the Marstons' chain, is a family friendly concern providing good-value food.

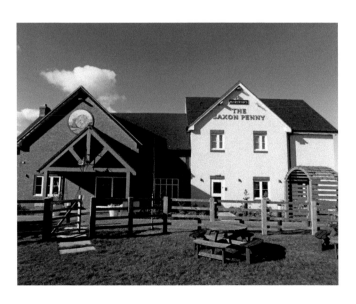

The Saxon Penny.

75. SHOULDER OF MUTTON/OWL, London Road (pre-1800–present)

The Shoulder of Mutton, now called the Owl, stands near to the crossroads of the London Road and the old Roman road of Ryknild Street. In the days of the coaching industry it was therefore situated on one of the most important coaching routes in the country.

The field adjoining the pub was at one time used for horse racing and gatherings of the South Staffordshire Hunt. The pub also stands near to the spot where criminals were hanged and their bodies displayed on gibbets, an area at one time called Gallows Wharf (now where the Shell petrol station is located).

The pub changed its name to the Owl in 2014 when it was totally refurbished and is now an out of the city pub/restaurant.

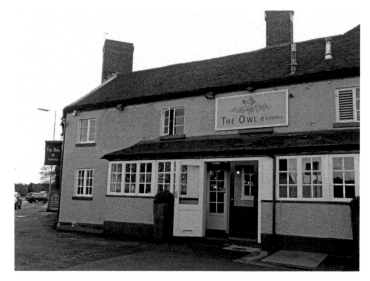

The Owl, previously the Shoulder of Mutton.

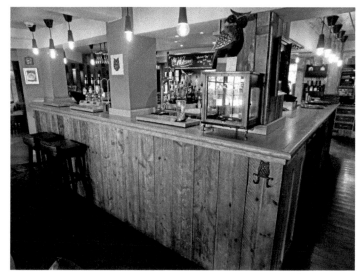

The Owl's central bar area.

76. TURNPIKE, Boley Park (1980s–present)

The Turnpike was part of the 1980s Boley Park building project, which at one time was said to be the largest such venture in Europe. Its name recalls the time in the eighteenth century when Lichfield roads were in the purview of the local Turnpike Trust. Traffic of all sorts entering the boundaries of the city was required to pay tolls and these were collected at toll houses. There were several of these placed at various points at the entrances to the city.

Above: The Turnpike, Boley Park.

Right: The Turnpike's pub sign echoes Lichfield's coaching days.

Other pubs in the outlying areas of the city that are now no longer in existence but have interesting histories include:

The Anchor (pre-1841–2015), which was located at Streethay just before the junction with the A38 towards Burton and Derby. It was first mentioned in 1841 when its licensee was William Titley. Between 1851 and 1891 the pub was managed by the Chamberlains, first John, who described himself in the census of 1851 as a wheelwright and innkeeper, and then by his wife Mary.

The closure of the Anchor was very recent and it is to be hoped that the pub will soon be up and running again as a going concern.

The Constitution Inn (1868–1956) stood on the Stafford Road on what is now a traffic roundabout near to Featherbed Lane with routes leading to Rugeley and Ashbourne.

Local historian J. W. Jackson recalled watching, as a child in the 1870s, a bare-knuckle prizefight in the field opposite the Constitution Inn. The fight lasted two hours and 'the blood flowed' freely before the contest was declared a draw, at which point the two fighters washed their battered faces and adjourned to the pub for, one imagines, some much-needed beer!

In March 1956 the licensing sessions decreed that the Constitution would close on account of the imminent redevelopment of the area and the pub, owned by Atkinsons Brewery, would have its licence transferred to the new Windmill pub in Wheel Lane. In June 1956 the pub closed its doors for the very last time but not before the landlady, Gertrude Wood, invited regulars to join her in a farewell celebration. In an interview, Miss Wood told the *Lichfield Mercury* that the inn was one of the 'quaintest in the city' and that she could remember when the pub had stables that were used by customers travelling to the Constitution on horseback. Seventy-nine-year-old Frank Horton, who lived in the cottage next door, told the newspaper that he had visited the pub for seventy-six years and related the story of how, as a three-year-old, he had been sitting on the steps of the pub when the landlady, Mrs Clay, came out and gave him a pint of beer! The newspaper concluded by saying that in spite of its isolated position the pub was a very popular one.

The Royal Oak (pre-1793–1965) was a beerhouse situated on the left-hand side on the road to Walsall just before the top of Pipehill. It was first mentioned in 1793 when the landlord was Mr Barisford. From 1886 until his death in 1936 the licensee was the grandly named William Napolean Hyde. Born in 1856 Mr Hyde was also a cooper and was the grandfather of another famous Lichfield publican, Horace Wilson, the last landlord of the Goat's Head Inn. The Royal Oak closed in 1965.

Also on the Walsall Road near to Pipehill was situated the Three Tuns (pre-1771–1990s). Its first documented landlord was Thomas Cooper, who ran the pub from 1771 to 1818. According to Kate Gomez and her highly informative blog, Lichfield Lore, it was Cooper who bought the pub and the land surrounding it in 1777 for £100. In 1801 he kept the pub, but sold the land for £1,498. The buyer was Henry Paget, Earl of Uxbridge and future second-in-command of allied forces at the Nattle of Waterloo.

In more recent times licensees endeavoured to attract customers to the pub by emphasising its long history and tradition. In April 1954 landlord and landlady

The interesting pub sign of the ex-Three Tuns.

Mr and Mrs Hutton opened the pub's new 'rustique bar', which had been specially designed to introduce an 'old worlde atmosphere' and a 'cottage effect' to the Three Tuns. The theme was continued in December 1968 when the licensees, Ray and Pat Brookes, advertised their pub as 'The olde worlde Inn noted for its good food at very reasonable prices.'

The Three Tuns was indeed a popular pub right up to its sad and untimely closure in the 1990s. It later became an Indian restaurant called Panache. That in turn has now gone and at the time of writing the building is in the process of being redeveloped as a pub/restaurant.

The Trent Valley Hotel (1877–2006) was positioned opposite the Trent Valley railway station and opened in 1877 to provide accommodation for travellers and food and drink for those waiting for trains. A horse omnibus from the station to the city centre, around a mile away, ran from the hotel and for many years it remained a busy pub, which also served those travelling by road to Lichfield from Alrewas and Burton-on-Trent and local farmers coming to the city with their produce. It closed in 2006 and is now a children's nursery.

The Windmill (1958-2010) had the distinction of being the first pub to be built in Lichfield following the Second World War. It stood on the corner of Grange Lane and Wheel Lane and opened its doors for the first time on 14 February 1958.

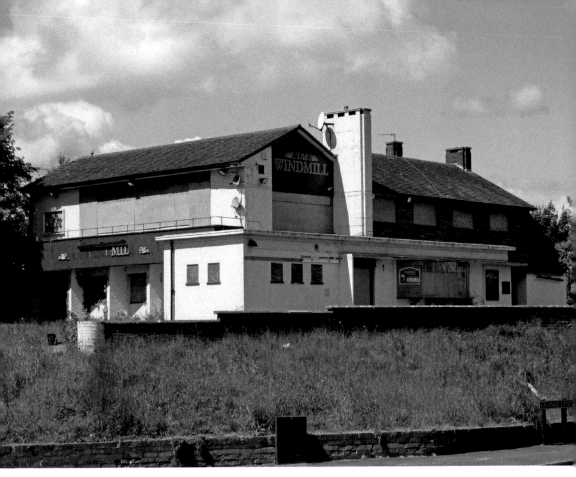

The sadly derelict Windmill pub.

Owned by Atkinsons' Brewery, it was described at the time as 'having all that was best in a modern pub building' including a temperature-controlled cellar and an upstairs assembly room that could seat ninety. It closed in 2010 and at the time of writing stands sadly derelict and presumably awaiting demolition.

The Yew Tree (pre-1833–*c.* 1870s) was a relatively short-lived pub on the Old Burton Road that would have served the traffic travelling between Lichfield and Burton before the building of the Trent Valley Road in 1853. The building still exists and is now called Yew Tree House.

Acknowledgements

The following books have been invaluable in discovering information about the pubs of Lichfield.

Foremost among them has been John Shaw's *The Old Pubs of Lichfield* (Lichfield 2001), which provided me with such an excellent starting point.

Also:

Bird, Vivian, *Staffordshire* (London 1974)
Boswell, James, *The Life of Samuel Johnson* (London 1848)
Clayton, Howard, *Coaching City: A Glimpse of Georgian Lichfield* (Lichfield 1970)
Clayton, Howard, *Cathedral City Howard Clayton* (Lichfield 1981)
Cockin, Tim, *The Staffordshire Encyclopaedia* (Stoke-on-Trent 2000)
Greenslade, M.W. (ed.), *The Victoria History of the County of Lichfield* (Oxford 1990)
Haughton, Brian, *Coaching Days in the Midlands* (Birmingham 1997)
Hopkins, Mary Alden, *Dr. Johnson's Lichfield* (New York 1952)
Philip Morgan and A. D. M. Phillips, *Staffordshire Histories* (Stafford 1999)
Rubery, Annette, *Lichfield Then and Now* (Stroud 2012)
Upton, Chris, *A History of Lichfield* (Chichester 2001)

Non-book sources

Staffordshire Directories for various years
The *Lichfield Mercury* – 1815 onwards
The *Lichfield Herald* – 1883
Aris's Birmingham Gazette – various years
Kate Gomez's blog 'Lichfield Lore'

Many thanks to Robert Yardley and St Mary's Heritage Centre for permission to use photographs of Lichfield's bygone pubs. Thanks also to the ever-helpful staff at Lichfield Records Office. My thanks must also go to Jenny Stephens and Phil Clement at Amberley Publishing.

Thank you too to all those Lichfeldians who kindly supplied me with help, stories and information, notably: Angie Allen, Sue Coley, John Rackham and Robert Yardley. Thank you to all those publicans who kindly allowed me to take pictures in their pubs and thanks also to their bar staff who have, over the years, supplied me with beer and friendly conversation.

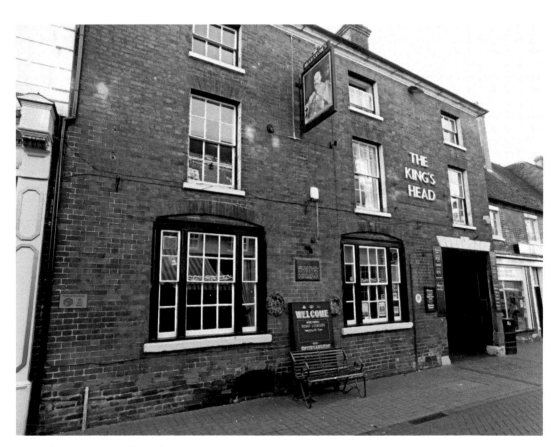

The King's Head, Bird Street.